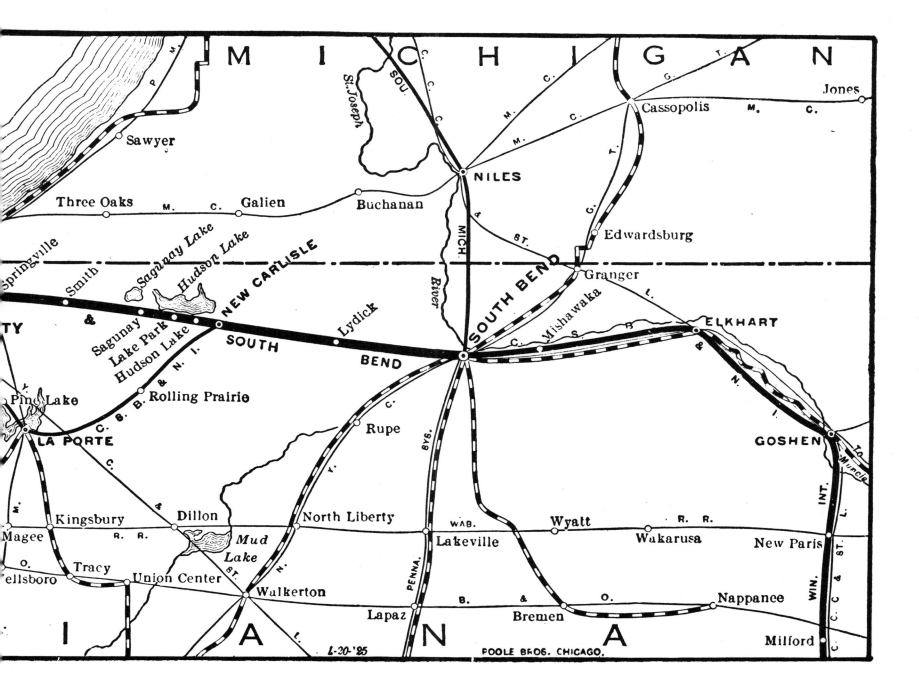

# MOONLIGHT IN DUNELAND

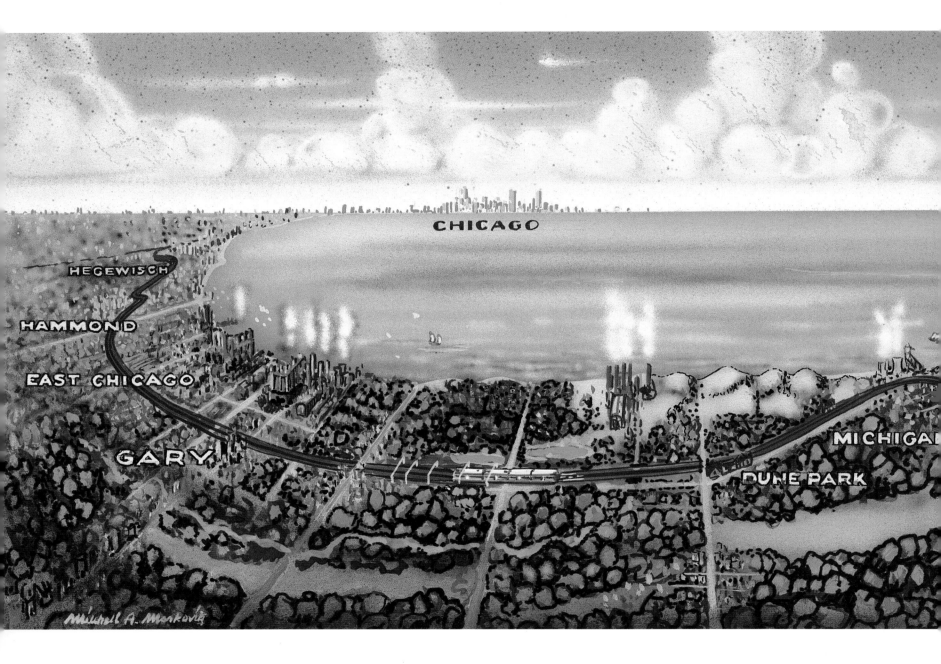

# MOONLIGHT IN DUNELAND

The Illustrated Story
of the Chicago
South Shore and
South Bend Railroad

EDITED BY
Ronald D. Cohen and Stephen G. McShane

INDIANA UNIVERSITY PRESS     BLOOMINGTON AND INDIANAPOLIS

This book is a publication of

Indiana University Press
601 North Morton Street
Bloomington, Indiana 47404-3797 USA

http://www.indiana.edu/~iupress

*Telephone orders* 800-842-6796
*Fax orders* 812-855-7931
*Orders by e-mail* iuorder@indiana.edu

The paper used in this publication meets the minimum
requirements of American National Standard for Information
Sciences—Permanence of Paper for Printed Library
Materials, ANSI Z39.48-1984.

Printed in Hong Kong

Moonlight in Duneland : the illustrated history of the Chicago
    South Shore and South Bend Railroad / edited by Ronald D.
    Cohen and Stephen G. McShane.
         p.   cm.
       Includes bibliographical references.
       ISBN 0-253-33418-7 (cloth : alk paper)
       1. Chicago South Shore and South Bend Railroad—History.
    2. Railroads—Illinois—Chicago Region—History. I. Cohen,
    Ronald D., date. II. McShane, Stephen G.  III. Chicago South
    Shore and South Bend Railroad.
    HE2791.C6849M66    1998
    769'.493855'0977311—dc21                              98-16812

1  2  3  4  5  03  02  01  00  99  98

Frontispiece: *Panorama of South Shore Line,*
Mitchell A. Markovitz, 1993.

TO NANCY, AS ALWAYS

AND

TO MOM AND DAD, CINDY, MAUREEN, AND RENÉE,
FOR THEIR STEADY, TIRELESS SUPPORT

# CONTENTS

List of Illustrations    ix

Acknowledgments    xi

Letter from Thomas McDermott, President, Northwest Indiana Forum, Inc.    xiii

Letter from the Northern Indiana Public Service Company    xv

Foreword, Victor Margolin    xvii

ONE

**Introduction**

Ronald D. Cohen and Stephen G. McShane / 1

TWO

**Insull's Super-Interurban**

William D. Middleton / 5

THREE

**Not Just Selling Railroad Tickets: The Role of the South Shore Line Poster Art in the Development of Northwest Indiana**

Bob Harris / 21

FOUR

**Commercial Illustration, Poster Painters, Railway Men**

Mitchell A. Markovitz / 27

FIVE

**South Shore Recreation: A Fun Way to Save a Railroad**

John Paul Laue / 33

THE POSTERS    43

Suggestions for Further Reading    135

About the Artists    137

Poster Retailers    138

"Just around the Corner"    139

# Illustrations

ii-iii    *Panorama of South Shore Line* (Markovitz, 1993)

5    *Dead Heat at County Line Road Crossing—Ideal Section* (Fleming, 1984)

21    *Beverly Shores* (Fleming, 1984)

25    *Where Homes Are Homes* (Medin, 1929)

27    *Gary, at Night* (Fleming, 1983)

28    *Conductor Boarding Train at East Chicago, 1929* (Markovitz, 1997)

30    *Dining Car, South Shore Line, 1929* (Markovitz, 1997)

31    *Michigan City Depot at Night, 1929* (Markovitz, 1997)

32    *South Shore Line's Indiana Limited, Crossing Calumet River, Heading for South Bend, 1929* (Markovitz, 1997)

33    *Little Train That Could* (Fleming, ca. 1973)

45    *Autumn in the Dunes via South Shore Line* (Hanson, 1925)

47    *Steel Mills at Gary by South Shore Line* (Erickson, 1925)

49    *25 Miles of Beach via South Shore Line* (Hanson, 1925)

51    *Winter in The Dunes: South Shore Line* (Hanson, 1925)

53    *Winter Sports in the Dunes by South Shore Line* (Hanson, 1925)

55    *The Dunes Beaches by the South Shore Line* (Urgelles, 1925)

57    *Football: Notre Dame (South Bend) by South Shore Line* (Hanson, 1925)

59    *Visit Duneland . . . via South Shore Line* (Johnson, 1925)

61    *Dunes Woodland by South Shore Line* (Hanson, 1926)

63    *Visit the Dunes Beaches by South Shore Line* (Brennemann, 1926)

65    *Visit the Dunes Beaches by South Shore Line* (Brennemann, 1926)

67    *Visit "The Workshop of America" by South Shore Line* (Brennemann, 1926)

69    *Homeward Bound by South Shore Line* (Hanson, 1926)

71    *Autumn: Indiana Dunes State Park by South Shore Line* (Brennemann, 1926)

73    *A Merry Christmas: South Shore Line* (Brennemann, 1926)

75    *Football: Notre Dame (South Bend) by South Shore Line* (Brennemann, 1926)

77    *Hudson Lake by South Shore Line* (Ragan, 1927)

79    *Springtime by South Shore Line* (Hanson, 1927)

81    *Indiana Dunes by South Shore Line* (Beard, 1927)

83    *Winter Sports in the Dunes by South Shore Line* (artist unknown, 1927)

85    *Indiana Dunes State Park: Only 81 Minutes from Downtown Chicago by South Shore Line* (Ragan, 1927)

87    *Moonlight in Duneland by South Shore Line* (Ragan, 1927)

89    *Winter Sports by South Shore Line* (Beard, 1927)

91    *The Dunes by South Shore Line: Visit Nature's Wonderland* (Ragan, 1927)

93    *Spring: Indiana Dunes State Park by South Shore Line* (Fahrenbach, 1927)

95    *Winter in the Dunes by South Shore Line* (Huelster, 1927)

97    *Season's Greetings: South Shore Line* (Ragan, 1927)

99    *Blossomtime in Michigan by Shore Line Motor Coaches* (Brennemann, 1927)

101    *Autumn in the Dunes by South Shore Line* (Beard, 1928)

103    *Duneland Beaches by South Shore Line* (Ragan, 1928)

105    *Winter Sports in the Dunes by South Shore Line* (Brennemann, 1928)

107    *Spring in the Dunes by South Shore Line* (Huelster, 1928)

109    *The Steel Mills by South Shore Line* (Berry, 1928)

111    *Ski Meet: Ogden Dunes by South Shore Line* (Biorn, 1929)

113    *Winter Sports by South Shore Line* (Graham, 1929)

115    *Indiana Dunes State Park by South Shore Line* (Huelster, 1929)

117    *Spring in the Dunes by South Shore Line* (Brennemann, 1929)

119    *Outward Bound by South Shore Line* (Huelster, 1929)

121    *Faithful Service: South Shore Line* (Markovitz, 1984)

123    *Taking Care of Business* (Markovitz, 1992)

125    *Recreation: Just around the corner along the South Shore Line* (Markovitz, 1997)

127    *Just around the Corner rests Indiana's Crescent Dunes . . . along the South Shore Line* (Markovitz, 1997)

129    *Chicago's Neighboring South Shore: Just around the corner along the South Shore Line* (Markovitz, 1997)

131    *Hoosier Prairie: A National Landmark. Just around the corner . . . along the South Shore Line* (Phillips, 1997)

133    *Strength and Beauty: Just around the corner . . . along the South Shore Line* (Rush, 1998)

# Acknowledgments

Compiling and editing *Moonlight in Duneland* involved many people. We are grateful for all of the advice and assistance given us over the past two years. With deep appreciation, we recognize the team effort of the Region 2000 Marketing Committee—John Davies, Bob Harris, Gary Hartman, Dennis Henson, Mitch Markovitz, Deborah Nordstrom, and Louie Ortiz—for their tireless commitment toward making *Moonlight in Duneland* a reality.

We are indebted to the many people who wrote letters of support for this project, including Kenneth Baur of Ben Franklin Crafts in Chesterton, Indiana; H. Terry Hearst of the Chicago SouthShore & South Bend Railroad (South Shore Freight); Gerald Hanas and John Parsons of the Northern Indiana Commuter Transportation District; Thomas McDermott, President of the Northwest Indiana Forum; Professor George M. Smerk of the Indiana University Institute for Urban Transportation; and Commissioner Lois Weisberg of the Department of Cultural Affairs, City of Chicago.

The research for this book was facilitated by members of the public, historical, and park library communities. In particular, we appreciate the assistance of Carol Derner and Ellen Petraits from the Lake County (Indiana) Public Library; Jane Walsh-Brown of the Westchester Public Library, Chesterton; Diane Ryan, Linda Ziemer, Leith Rohr, Cynthia Matthews, and Matthew Cook of the Chicago Historical Society's Prints and Photographs Department; Wendy Smith and her staff at the Indiana Dunes State Park Nature Center; and David Lewis of the Indiana State Library. In addition, we appreciate the information and suggestions provided by South Shore Line poster history expert David Gartler of Poster Plus in Chicago, as well as *Vintage Rails* magazine editor John Gruber and author J. J. Sedelmaier, for their excellent articles about the posters.

An indication of the interest in the South Shore Line posters was provided by the first public exhibition of original posters preserved in the Calumet Regional Archives. The August 1997 exhibit at the Northern Indiana Arts Association in Munster received phenomenal attention. Thanks to the professionalism and enthusiasm of NIAA Executive Director John Cain and Exhibit Curator Linda Dorman Gainer, the exhibit served as a valuable means of exposure for these splendid works of art.

Many local individuals gave much of their valuable time to help us with leads, suggestions, and guidance for improvements to our publication. Ed Hedstrom and Bill Janssen, veteran employees of the South Shore Line, generously allowed us to view their railroad memorabilia. Carl Reed of Beverly Shores furnished valuable insight into the railroad's marketing campaigns. We very much appreciate the assistance of the administration, faculty, and staff of Indiana University Northwest. In particular, Professor James B. Lane and Library Director Robert F. Moran offered continued encouragement and support.

We also gratefully recognize the efforts of our contributors. John Paul Laue devoted countless hours to this project. He examined collections of South Shore graphics, lent us images for publication, and authored an essay that is entertaining, informative, and insightful. Artist Dale Fleming's railroad scenes provide a delightful and poignant visual interpretation of the South Shore Line's legacy. Thanks also to William D. Middleton, for providing us with a fascinating narrative of this railroad's history by allowing us to reprint a portion of his work, *South Shore: The Last Interurban.* And artists Alice Phillips and John Rush graciously added their unique perspectives of the Calumet Region through their contributions to the new Northwest Indiana poster series.

Three individuals deserve special mention. First, John Davies, Vice President, Marketing, of the Northwest Indiana Forum has our eternal gratitude. John's vision, energy, and drive inspired us to produce a quality publication. He not only garnered financial underwriting but also selflessly contributed his outstanding research on the poster artists for use in the introduction of this book. He has been *Moonlight in Duneland*'s greatest champion and promoter.

Next, without Bob Harris, *Moonlight in Duneland* would not exist. Bob brought the invaluable South Shore Line; North Shore Line; and Chicago, Aurora & Elgin posters to the Calumet Regional Archives at Indiana University Northwest, creating one of the largest known collections of original posters produced by these railroads. Thanks to Bob, present and future generations may enjoy viewing these precious historical works of art. He manifested his generosity in countless ways, from funding the production of color transparencies to writing a superb essay. For Bob, *Moonlight in Duneland* was a labor of love, and we appreciate his many contributions more than we can say.

Finally, we must acknowledge the incredible talents of Mitchell A. Markovitz. A truly exceptional artist (who is also a South Shore Line locomotive engineer), Mitch's work can be seen throughout this book. His donation of text and artwork has proven invaluable to us. His interpretation and skill in capturing the magnificence of the Calumet Region on canvas is truly a marvel. Mitch's destiny was to follow in the footsteps of South Shore Line poster artists Oscar Rabe Hanson, Otto Brennemann, and Leslie Ragan—he is a worthy successor.

RONALD D. COHEN
STEPHEN G. MCSHANE

**Northwest Indiana
Forum, Inc.**

6100 Southport Road
Portage, Indiana 46368

(219) 763-6303
Fax-(219) 763-2653

The colorful posters of the South Shore Line are timeless treasures of art and are to Northwest Indiana and the Midwest what Currier & Ives prints are to the nation. Generations have been drawn to these posters that stand out as "beloved faces in a crowd" showing the dunes, the sunny lakeshore beaches, the forests and our steel mills. Indeed, they are as timely today as when they were first created to attract Chicagoans to visit and live here between 1925 and 1929.

The Northwest Indiana Forum is pleased to support this historic collection and commends the Calumet Regional Archives of Indiana University Northwest and the sponsors of this beautiful book. At the same time, we join with the business community in support of the arts in launching a new series of South Shore posters showing scenes today of our outstanding recreational, residential, commercial and industrial life. To this end, several of the new paintings are featured in this collection and it is our hope that this new series will rekindle the enthusiasm and pride of new generations of people throughout the Midwest about our special quality of life.

As we prepare ourselves for the 21st century, there is no greater challenge than showing the world our remarkable transformation to a community dedicated to sustaining our economy while preserving our environment. This book is an important step toward helping people appreciate both the enduring legacy of our art, and the amazing resilence of this Region in Renaissance. Again, we hope you enjoy this collection and join a growing number of newcomers and residents who appreciate Northwest Indiana as one of the premier places in the Midwest for work, for play, for life.

Thomas M. McDermott
President, Northwest Indiana Forum

# Northern Indiana Public Service Company

5265 Hohman Avenue ● Hammond, Indiana 46320-1775 ● (219) 853-5200

*A subsidiary of NIPSCO Industries, Inc.*

Northern Indiana Public Service Company (NIPSCO) places great emphasis on initiative and creativity. We believe that our support of Indiana artists serves to drive economic growth in northern Indiana. For this reason, we salute the Calumet Regional Archives, Indiana University Northwest, the Northwest Indiana Forum, and the Region 2000 Marketing Committee for providing the public with this unique opportunity to view not only these remaining South Shore Line poster reproductions in book form, but also to preview a new poster art campaign that we hope will be among the greatest contributions to economic marketing since the early 1920s.

NIPSCO's association with the early South Shore Line posters dates back to the mid-1920s when Samuel Insull formed the Midland Utilities Company, purchasing the stock of the Calumet Electric Company and many other small isolated properties in Indiana, Michigan and Ohio. In 1923 Midland acquired Northern Indiana Gas and Electric Company from the United Gas Improvement Company. The name of the Calumet Electric Company was changed to the Calumet Gas and Electric Company and the two properties operated as independent subsidiaries.

Beginning in 1922, the companies headed by Samuel Insull launched a marketing campaign that produced posters focusing on scenes and civic attractions outside Chicago in Indiana, Wisconsin and along the North Shore. As stated in *Electric Traction Journal,* " No form of advertising has attracted as much attention, or caused as widespread favorable comment, as the lithographed posters." The posters, a tribute to the unusually creative advertising styles of the interurban railroads, present an important graphic record of urban America in the 1920s. On January 28, 1926, the name of the Calumet Gas and Electric Company, a subsidiary of the Midland Company, was changed to Northern Indiana Public Service Company.

Today NIPSCO is one of four regulated businesses of NIPSCO Industries, Inc. (NI), an energy/utility-based holding company. These four regulated businesses are primarily energy or utility focused and include marketing and trading; power generation; oil and gas exploration and development; gas transmission, supply and storage; and related products targeted to customer segments.

Enhancing northern Indiana's economic viability and its reputation as a desirable place to live and work is a priority at NI. Economic development activities, neighborhood assistance programs, youth services and environmental awareness play an important role in our commitment to corporate citizenship. Building on the accomplishments of our early utility industry visionaries and mindful of their past deeds, we too seek to challenge new horizons guided by the richness of our noble past.

Northern Indiana Public Service Company

# *Foreword*

Victor Margolin

The poster as a form of public address has a long history that some scholars trace back to the notices posted on walls in classical Greece. However, its potential as a pictorial medium was not exploited until after the invention of lithography in 1796. Early lithographic posters mirrored the most conservative academic painting and were largely produced by anonymous artists. But at the end of the nineteenth century, the poster came into its own as an art form thanks to Jules Chéret, a French artist who had studied lithography in England. Chéret produced hundreds of expressive posters that publicized the dance halls, fêtes, and even commercial products of France's "belle époque." Artists across Europe followed Chéret's lead, and by the end of the century the poster was recognized as a strong graphic medium in many countries including England, Belgium, Austria, Germany, Italy, and Spain.

In the United States there was a "poster renaissance" in the 1890s that featured the work of many artists such as Will Bradley, Edward Penfield, Maxfield Parrish, Ethel Reed, and J. C. Leyendecker. The lead came from publishers, primarily in New York and Chicago, who began using lithographic posters to promote their new books and magazines. In Chicago, Will Bradley, who created a highly original graphic style with strong influences from the British Arts and Crafts Movement and Art Nouveau, was a major figure. His posters for *The Chapbook*, one of the small literary magazines of the day, and his covers for *The Inland Printer* helped to give a modern look to American poster and magazine art.

By the beginning of the twentieth century, Chicago had become a major center of printing activity. This meant a lot of work for illustrators, layout men, and typographers. Several art schools, including the School of the Art Institute, included poster design in their curriculum, and this resulted in a pool of illustrators in Chicago who were familiar with that medium. It is not surprising then that the South Shore Line could find enough artists to produce a noteworthy series of monthly posters over a four-year period.

The work of Ivan Beard, Oscar Rabe Hanson, Otto Brennemen, Leslie Ragan, and others who designed posters for the South Shore Line, as well as the North Shore Line and the Chicago Rapid Transit, was not ground-breaking in terms of graphic innovations. It was good solid figurative work. The flatness of the drawing in many of the posters, however, does suggest an awareness of the German *sachplakat* or "fact" poster made famous by Lucian Bernhard, Ludwig Hohlwein, and other artists in Berlin and Munich only a few years earlier. The thick letters on many of the South Shore Line posters, sometimes with lighter outlines around them, recall the lettering of Bernhard in particular, though for Bernhard a large object such as a shoe or light bulb with a single brand name in oversized characters was sufficient. His work was less illustrative than the posters for the South Shore Line, but their purpose was also different. Both Bernhard and Hohlwein were depicting icons of

culture—new products in a decidedly modern form. The posters for the South Shore Line were largely about nature, with the exception of those in the Workshop of America series. The artists were surely asked to portray the natural beauty of northern Indiana in a way that would make the sites appealing to potential visitors. Even if cubism and the other isms of modern art had gained a stronger foothold in America by the 1920s, an avant-garde style was not what was called for in these works.

There is some precedent for the series of South Shore Line posters in the placards that Frank Pick began to commission for the London Underground beginning around 1921. Like the South Shore posters, the aim of the London Underground campaign was to increase the number of riders by calling attention to places of interest that could be reached by train. But unlike the South Shore Line series, which ended several years before the railroad declared bankruptcy, the London Underground series continues today. Perhaps there is some echo of this continuity in the contemporary posters by Mitchell Markovitz, Alice Phillips, and John Rush that are included in this volume.

It was not until the 1960s that an equally ambitious program of poster art was created in Chicago. At that time, the Center for Advanced Research in Design (CARD), a studio which was part of the Container Corporation of America, created a series of posters that promoted interesting places to visit in the city. The primary difference between the two series, however, is that the South Shore Line placards were done in an easily accessible, figurative style while the CARD posters used a more abstract conceptual approach that drew heavily on the modern design movement in Switzerland.

Rich in mood but conservative in form, the South Shore Line posters were very much products of their time and place. Today, they recall for us a romantic vision of the northern Indiana landscape. As the authors in this volume note, they were extremely effective in convincing Chicagoans to go to Indiana and experience the dunes and beaches for themselves.

# MOONLIGHT IN DUNELAND

# INTRODUCTION

Ronald D. Cohen and Stephen G. McShane

The Chicago South Shore and South Bend Railroad has had a colorful history. Today, while providing daily transportation for thousands of travelers to and from Chicago, the South Shore Line continues to inspire nostalgia. Two images immediately come to mind: the old orange cars (phased out in the 1980s) and the dozens of colorful posters issued in the 1920s, depicting the diverse natural and industrial sights of Northwest Indiana. Miraculously surviving as the country's last electric interurban railway, the South Shore Line has been an object of fascination for numerous artists since the Roaring Twenties. This ongoing connection between artistic sensibilities and efficient, electric rail service from Chicago across much of northern Indiana has inspired *Moonlight in Duneland.*

The railway line's inconspicuous beginnings date from December 2, 1901, with the incorporation of the grandiose-sounding Chicago & Indiana Air Line Railway. Two years later the company's two suburban cars ran between East Chicago and Indiana Harbor, Indiana—a distance of less than four miles. But the owners had bigger plans for their interurban line. As industrial and residential development took off along the southern shore of Lake Michigan, the owners signaled their intentions in 1904 by changing the name of the line to the Chicago Lake Shore and South Bend Railway. The incorporation of Gary and the construction of the world's largest steel mill, in 1906, by the United States Steel Corporation spurred expansion of the Lake Shore Line eastward to South Bend. In September 1908 service was initiated between South Bend and Hammond; within a few months the line stretched into Illinois and in 1912 began limited service to Chicago. Efficiency increased over the next decade, and by 1924 the Lake Shore Line was one of the fastest interurbans in the country. Initially limited to passenger and package freight service, carload freight service was added in 1916 and proved to be somewhat lucrative. At that time, sixteen thousand miles of interurban rail lines spanned the country, providing vital passenger and freight transportation links.

Despite the Lake Shore Line's achievements, use declined through the early twenties, resulting in deferred maintenance, increasingly shabby cars, and rising debts. Along with other interurban lines throughout the country, it appeared that the Lake Shore Line's days were numbered. "Popular preference for the private auto over mass transit translated into a public policy that pumped hundreds of millions of dollars into city, county, and state road-building projects in the metropolitan area," Harold Platt explains in *The Electric City: Energy and the Growth of the Chicago Area, 1880–1930.* He continues:

> The massive public works program was matched by private construction of the accouterments of a car culture, including garages, drive-ins, road-side motels, and other tourist accommodations. Public subsidy of the automobile in the form of highway construction helps account for the decline of the streetcar and elevated companies, which continued to operate under the debilitating burdens of political controversy and heavy taxes. (252)

In spite of this discouraging situation, the Lake Shore Line found a savior in Samuel Insull, the utilities magnate then in the midst of expanding his industrial empire. Insull, at the age of twenty-one, had immigrated from England in 1881 to be Thomas Edison's private secretary: thus began his fortuitous connection with the father of the industrial development of electricity. Within a few years he had worked his way up the corporate hierarchy at General Electric. He moved to Chicago in 1892 and became president of the Chicago Edison Company. Within three decades he managed to monopolize the supply of power in the region. In 1923, Insull branched out into Northwest Indiana with the formation of the Public Service Investment Company, soon renamed Midland Utilities Company. He had expanded his business interests to include electric railways after 1911, and had taken over the troubled Chicago North Shore & Milwaukee interurban line in 1916, so there was little surprise when, in 1925, he purchased the ailing Lake Shore Line and promptly renamed it the Chicago South Shore and South Bend Railroad. And in the following year he took over the Chicago Aurora and Elgin. Insull's miraculous, and expensive, resurrection of the South Shore Line during the late 1920s is recounted by William D. Middleton in *South Shore: The Last Interurban* (reprinted in part as chapter 2 of this volume).

The South Shore Line's remarkable growth up to the time of the Great Depression resulted from a combination of greatly improved service and a shrewd marketing campaign. The railroad's advertising efforts included colorful brochures, newspaper ads, maps, newsletters, and even movies. The centerpiece of the promotional campaign for the South Shore Line, however, was a series of beautiful, unique posters depicting a variety of scenes along the railroad's route. Perhaps as many as fifty different lithographed color posters, displayed in railroad depots, on Chicago "L" platforms, and elsewhere, highlighted fun in the Indiana Dunes, plentiful local flora and fauna, and the contrasting majesty of the flourishing steel industry—all characteristic of the Calumet Region of Indiana.

Commercial poster art has had a long, glorious history. An article in *The Poster*, July 1927, described how posters were chosen for a major advertising campaign to educate the public concerning the dangers of railroad crossings. Preferred over bulletins and other written forms of communication, the poster "delivers a message at a glance." One railroad official added, "People will read a poster and will even study it carefully and get a lesson from it; folks who would never think of reading a message that is printed briefly, much less even a brief book . . . what they see on the poster gets results—they get a vivid impression."

In the foreword to the 1927 *Annual of Advertising Art* (which included the South Shore Line poster *Homeward Bound*, p. 69), W.H. Beatty stated:

> You are viewing here the best of art used by business. For advertising, as you know, is the principal means whereby business talks to its public. It was business that paid for these pictures while the members and adherents of the Art Directors Club reared and nurtured them into the beauty you see canonized here for the sixth year between the covers of this book. Hence you should expect to find the same flux and movement as you discern in commerce itself. All of which means that advertising art, must be and is lively art, not to be confused with the reposeful static kind of

expression that one expects to find in museums pungent with historic camphor. These pictures represent much experimentation and daring, much reaching out for the new, as they should, for they reflect the same churning, endlessness that competitive business does, if not for American life itself. Perhaps when a future historian of this American scene has relegated such things as business profits, quotas and earnings to footnotes on the bottom of his page . . . it will be bits of pageantry like this that will appeal to him.

Among the South Shore artists, Oscar Rabe Hanson received the most honor. His studio, in Chicago's Fine Arts Building, also housed Frederic Willard Elmes and Arthur A. Johnson, each of whom designed posters for the South Shore Line, the North Shore Line, and the Chicago Elevated. In 1926, Hanson's studio moved to "Towertown" (near the famed Chicago Water Tower). The following year three Hanson posters—*Winter in the Dunes* (p. 51), *Dunes Woodland* (p. 61), and *Homeward Bound* (p. 69)—were accepted for the Sixth Annual Exhibition of Advertising Art. *Homeward Bound* won medals from the Art Directors Club and Barron Collier, presented posthumously to Hanson.

Leslie Darrel Ragan was born in Woodbine, Iowa, in 1897. He began his art education at the Cummings School of Art in Des Moines and also studied at the School of the Art Institute in Chicago. He had a studio in Chicago and taught at the Chicago Academy of Fine Arts and the Art Institute for several years before moving on to New York, California, and Europe. In 1927 and 1928 he created at least six South Shore Line posters, and later he produced over 100 posters for the New York Central Railroad. Until his death in 1972, he continued his prolific career with other rail companies, including the Norfolk & Western and the Budd Company.

German-born Otto Brennemann, with a background in automotive design, became a technical draftsman while serving in the German Army during World War I. After the signing of the Treaty of Brest-Litovsk, he became commander of an armored car column and advanced into the Ukraine, remaining on Russian soil until the war's end. Unable to return to Germany because of continued fighting with the Communist government, his men were finally rescued, only to find themselves held captive by the Turkish government for another three months. Back in Germany he resumed his commercial art until he emigrated to the United States. At first he worked on the art staff of *Popular Mechanics,* but soon he began to concentrate on poster design. Asked about the future of American poster art, he remarked:

> It is progressing at a rapid rate, although sometimes I wish that the American people might show more discrimination in the qualities of the arts and appreciate rather the original thought of an artistic creation than merely its superficial exterior. The cultivation of this appreciation being largely a matter of sufficient leisure and study, it may not be reasonably expected yet.

Unfortunately, little is known about the other South Shore Line poster artists, but all were chosen for their talent and artistic sensibility. Their posters are not about trains—indeed, only one includes a tiny train in the distance—but rather they explore the changing textures and colors of the Region, enticing curious visitors from Chicago to vacation and to investigate, and perhaps to invest. Ostensibly advertisements for tourists, the posters had another function, as Bob Harris explains in "Not Just Selling Railroad Tickets: The Role of the South Shore Line Poster Art in the Development of Northwest Indiana." Suburban residential development was also high on Insull's agenda, promoting greater power usage and thus enabling the Fred'k Bartlett Realty Co. to prosper as well by selling lots along the lakeshore.

"Like the automobile and the interurban railway, modern utility services helped open the 'crabgrass frontier' to homes, businesses, and industry," Harold Platt notes (252).

The symbiosis of art and commerce found fertile soil in the South Shore Line poster project of the 1920s and has continued in recent decades. During the 1970s, as the South Shore Line once again struggled to survive, citizens in Indiana and Illinois organized as pressure groups. As John Paul Laue recounts in "South Shore Recreation: A Fun Way to Save a Railroad," South Shore Recreation, based in Chicago, used all manner of tactics, including reproducing some of the original posters, to garner the requisite political support. They were successful, and in the late 1990s the South Shore Line remains the lifeline for thousands of commuters to Chicago.

But just as the original posters were also designed to foster expanded development of northern Indiana, in 1997 the Northwest Indiana Forum initiated a new poster project to stimulate interest in residential, commercial, and industrial growth. We are proud to include not only two South Shore Line posters and other scenes of the railroad by Mitchell A. Markovitz, but also his three most recent illustrations for the ongoing Northwest Indiana Forum campaign. In addition to his artwork, Mitch has added perspectives on the 1920s poster artists as well as on his own career as a South Shore Line locomotive engineer, art director, and illustrator in "Commercial Illustration, Poster Painters, Railway Men." The talents of other artists have been tapped for the series as well: Alice Phillips and John Rush have added their own dimensions and are also represented in this volume.

Commercial poster art continues to bring together art and commerce and to connect the Region's thriving present as "A Region in Renaissance" to its colorful past. Through these insightful, sometimes personal, essays and the numerous illustrations, both historical and contemporary, we hope to provide a helpful context for understanding and appreciating the beauty of the thirty-eight original South Shore Line posters that we have assembled for this book.

# INSULL'S SUPER-INTERURBAN

William D. Middleton

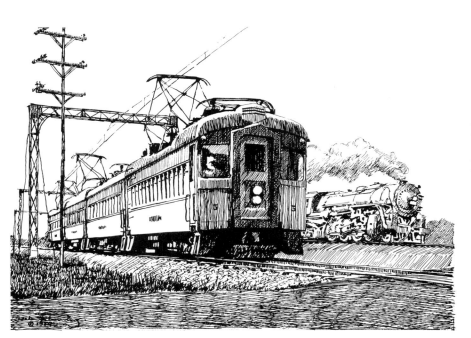

*Dead Heat at County Line Road Crossing—Ideal Section,* Dale Fleming, 1984.

In the American business world of the 1920s Samuel Insull was a man of almost legendary reputation. Born in obscurity in London, England, in 1859, Sam Insull had risen to his prominence in the public utilities industry through a combination of immense energy and exceptional management ability.

At the age of 21 Insull came to the United States as private secretary to inventor Thomas A. Edison. Before Insull was 30 Edison sent him to Schenectady, New York, to manage his new electrical manufacturing plant, which ultimately was to grow into the great General Electric Company. Leaving GE in 1892, Insull set out on his own in the then infant central station power business, becoming president of the Chicago Edison Company.

During the next several decades the Insull-managed company, which later became the giant Commonwealth Edison Company, pioneered much of the technology and the business methods which spurred the extraordinary growth of the electric power industry early in the 20th century, and became the cornerstone of a mammoth Insull-controlled public utilities empire that by 1930 was worth somewhere between two and three billion dollars; generated a tenth of the nation's electricity; and provided electric, gas, and transportation service to some 5,000 communities in 32 states.

Although his efforts had been largely in the public utilities field, Samuel Insull was by no means a newcomer to the electric railway industry when his Midland Utilities Company acquired control of the South Shore Line in 1925. Indeed, Insull's interest in electric railways dated as far back as the early 1880s, when he had participated in some of Thomas Edison's pioneering experiments in railroad

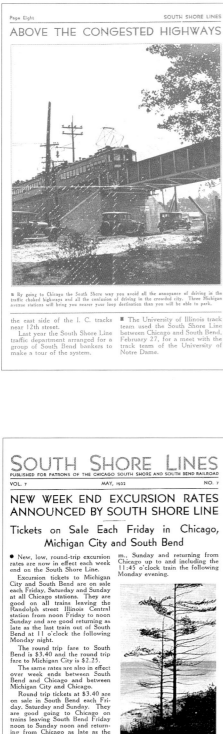

electrification, and in later years he had come to believe that electric transportation would ultimately supplant all other means of mass transportation.

Beginning in 1914, when the Chicago elevated system was unified under his control, Insull began acquiring widespread financial or management control of electric railway properties. By the time he assumed control of the South Shore, the Insull traction empire included an almost unbroken chain of interurban properties extending from Milwaukee to Louisville, and the electric railway trade press was giving serious attention to rumors that a single giant Insull interurban system was in the making.

Intriguing as the prospects of through interurban operations over such a system might have been, the Insull interest in the South Shore Line stemmed from more realistic considerations. Despite the dismal financial performance of the predecessor Chicago, Lake Shore & South Bend, the region served by the South Shore Line remained one of exceptionally great promise for an interurban railway. The South Shore Line provided a direct link between Chicago and several of the largest cities in Indiana, and between 1907 and 1925 the population in the area directly tributary to the railway had more than doubled, from 175,000 to 390,000. Industrial development in the Calumet District served by the South Shore had continued unabated since the beginning of the century. Already familiar with the great potential of the northwestern Indiana area through the gas and electric power operations of its utilities subsidiaries, Insull's Midland Utilities Company held an enthusiastic view of future prospects for the South Shore Line.

During the several years immediately previous, an Insull management had capitalized on an almost parallel situation, transforming the bankrupt North Shore Line into one of the finest—and most profitable—properties in the entire interurban railway industry. Sam Insull was confident that the same formula could be successfully applied to the South Shore Line.

Reorganization of the South Shore under Insull management brought a formidable array of management talent to the line. Insull himself was elected chairman of the board. Britton I. Budd, who had been picked by Insull to head Chicago's consolidated "L" system in 1914 and who had directed the North Shore's reconstruction as the line's president following its reorganization in 1916, was elected president of the South Shore. The utilities tycoon's son, Samuel Insull, Jr., who was a vice president of Midland Utilities and had carried out the negotiations that resulted in Insull control of the South Shore, was elected a vice president and directly supervised the reconstruction of the South Shore. Two remaining vice presidents of the new company, Bernard J. Fallon and Charles E. Thompson, were both officers of the North Shore Line. Charles H. Jones, formerly electrical engineer for both the North Shore Line and the Chicago Rapid Transit, was appointed general manager of the South Shore soon afterward.

With an announced objective of developing a standard of freight and passenger service that would place the South Shore "above competition," the new management immediately initiated a massive reconstruction program for the deteriorated property. Within two months 400 to 500 men were at work on rehabilitation of the railway, and by December 1st the labor force reached a peak of more than 900 men. By the end of the year well over a half million dollars had been expended on the reconstruction work.

During the first few months efforts were largely concentrated on the rebuilding of the railway's track and roadbed. By October a total of 13 track gangs were at work. The entire line between Kensington and South Bend was resurfaced, requiring a total of 300 cars of cinder ballast by the end of the year. Close to 40,000 new creosoted ties were placed, and 11,000 pairs of heavier angle bars were installed throughout the main line. Between Kensington and Hammond some ten miles of

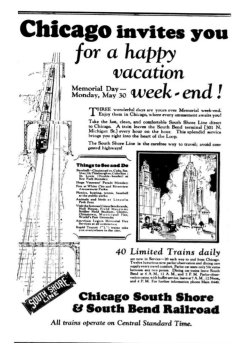
the railway's most heavily traveled double track line were graded, reballasted with crushed rock, and relaid with 100 lb. rail in place of the original 70 or 80 lb. rail. Work was started on a program to lengthen and double-end sidings and to equip them with high speed turnouts, in order to allow the operation of longer freight trains and to permit high speed meets.

Throughout the length of the line the roadbed was widened and drainage ditches improved. Highway crossings were cleared of trees and underbrush which obscured vision, and the entire line was cleared of weeds and other growth. Several new bridges were installed, and all steel structures and bridges were cleaned and painted. Telephone lines were replaced, and the railway's entire block signal system was rebuilt.

Indicative of the advanced state of deterioration of the latter system is a recollection of Samuel Insull, Jr., of a pre-rehabilitation trip over the line. On one section of the line, he recalled, five out of seven block signals were being run on order, or disregarded, by train crews because they were out of service.

Freight stations and platforms were enlarged, and painted in the railway's new standard orange and mahogany color scheme. A new passenger station was opened at La Salle and Michigan streets in South Bend. The stations at Gary and Tremont were rebuilt and that at Michigan City was remodeled and painted. A standard design was developed for the building of shelters at all local stops.

Before the end of the year the South Shore had placed orders totaling well over a million dollars with the Pullman Car & Manufacturing Corporation for 25 new steel passenger coaches, two dining cars, and two parlor-observation cars. In anticipation of a greatly increased freight traffic, four new 80-ton freight locomotives were placed on order from Baldwin-Westinghouse at a cost of almost a quarter million dollars.

Without waiting for delivery of its new passenger cars, the South Shore set out to improve passenger service with its existing equipment. Interiors of the original Niles and Kuhlman cars were refurbished, and the cars were repainted in the new orange and mahogany colors. Greatly expanded schedules were placed in effect; by the end of 1925 the company was operating 28 more daily trains than a year previous. Passenger revenues showed an almost immediate increase.

Although the initiation of through coach service over the Illinois Central to Chicago in 1912 had somewhat improved the railway's traffic volume to and from Chicago, the delays incurred in changing motive power and the limited number of through trips had remained a barrier to development of the full traffic potential. One of the principal considerations that had affected the Insull decision to acquire and rebuild the South Shore Line was the opportunity afforded by the impending electrification of Illinois Central's suburban lines to finally overcome this handicap.

Operating as it did along the Chicago lake front, the IC service had always been the target for smoke abatement criticism. In 1912 the City of Chicago had finally forced the issue with an electrification ordinance which required electrification of IC's suburban service by 1927. By 1925 IC was well along with a $50 million terminal improvement program that included not only electrification, but substantial right-of-way improvements as well. Opening of the electric service was planned for the summer of 1926.

In addition to the close ties that had historically existed between the South Shore and the Illinois Central, the Insull interests also had a close relationship with IC at this time. Insull's Commonwealth Edison represented IC's largest coal shipper, and the IC in turn, with its new electrification, represented one of Commonwealth Edison's largest power customers. Even before assuming control of the South Shore the Insull management negotiated a contract with IC that granted South Shore trackage rights for through operation of all trains directly into IC's Randolph Street Station.

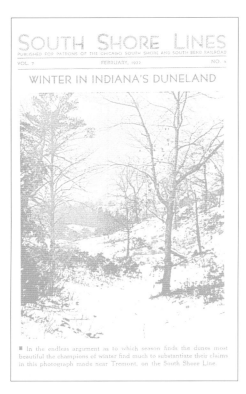

■ In the endless argument as to which season finds the dunes most beautiful the champions of winter find much to substantiate their claims in this photograph made near Tremont, on the South Shore Line.

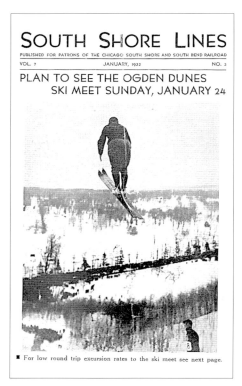

■ For low round trip excursion rates to the ski meet see next page.

Because the Illinois Central electrification employed a 1,500 volt direct current system, through operation of South Shore trains required not only entirely new motor equipment, but the complete replacement of the South Shore's original 6,600 volt A.C. system. By the end of 1925 the South Shore had begun work on a complete renovation of its overhead distribution system and installation of the new equipment required for D.C. operation. The entire original catenary trolley wire system was replaced, utilizing only the original wood poles, which were found to be in excellent condition. Between Kensington and Hammond new steel supporting trusses for the overhead system were installed on the original poles. Near Miller, Indiana, an "ideal" section of new overhead system was installed on a mile of double track as a prototype for eventual replacement of the entire overhead supporting system. Steel catenary bridges, virtually identical to those used on the North Shore Line's new Skokie Valley Route, were installed at 300 foot spacings, supporting a three-wire catenary system.

To supply the D.C. power, the Northern Indiana Public Service Company, another Midland Utilities subsidiary, began the installation of the necessary feeders and the construction of eight new substations, at Hammond, Gary, Ogden Dunes, Tremont, Michigan City, Tee Lake, New Carlisle and South Bend. Five were of 1,500 k.w. capacity while the remainder were 750 k.w. stations. Among the advanced features of the electric installation were the provision in four of the new substations of a new type of automatic mercury-arc rectifier, and the use of a carrier current type of supervisory control which permitted centralized control of power supply for the entire railway. Both of these features represented the first such installations on any U.S. railroad.

Deliveries of the new Pullman motor cars began in June 1926. Constructed entirely of steel, the new cars were 60 feet in length, 10 feet 6 inches wide, and weighed 60 tons, representing some of the heaviest cars of their length ever built. Each car was equipped with four 200 h.p. Westinghouse No. 567-C motors, and was mounted on seven foot wheelbase Baldwin type 84–60 AA high speed, heavy duty trucks. The cars were fitted with Westinghouse HBF electro-pneumatic multiple unit control, and were provided with both a pantograph and a trolley pole for current collection.

Ten of the cars were arranged as combination baggage-passenger cars, seating 44 passengers, while the remainder were full coaches, seating 56 passengers. All 25 were provided with separate smoking compartments and two toilet compartments. The cars were equipped with standard steam railroad type vestibules and diaphragms to provide a fully enclosed passage between cars, the first interurban equipment ever so equipped.

Interiors of the cars were finished in rich brown mahogany woodwork, with light cream ceilings and battleship linoleum flooring. Seats were upholstered in deeply cushioned green mohair velvet, or with Pantasote in smoking compartments. Interior trimmings were of statuary bronze, and electric fans and large dome lights were installed. Thermostatically controlled dual electric and hot water heating systems were installed. The electric heaters were sufficient for normal heating requirements, with the hot water system being placed in operation only in extremely cold weather.

Following delivery of a portion of the new steel equipment, the overhead system between South Bend and Michigan City was cut over to 1,500 volt D.C. and the new cars placed in service on July 13, 1926. At the same time three of the new D.C.-equipped Baldwin-Westinghouse freight locomotives were placed in service east of Michigan City. A.C. operation with the old equipment continued west of Michigan City, with trailers operating clear through. D.C. operation was extended to Gary a week later, and the entire line was cut over to D.C. on July 28th. For a short time, pending completion of the IC electrification, the South Shore's new steel cars were hauled to Randolph Street behind steam locomotives. Finally, on August 29,

electric operation over the IC line was initiated, and for the first time in its history the South Shore was able to offer a full, direct passenger service to the heart of Chicago. New schedules provided for the operation of 56 daily trains, including 31 limited trains. Hourly limited train service was available between Chicago and South Bend throughout the day, and running time between the two terminals was cut by 20 minutes.

In just the first year of Insull management the South Shore Line had invested almost $2.8 million in rehabilitation and improvements to the property and for new equipment, while Northern Indiana Public Service had spent another $857,000 for the installations necessary to convert the railway to D.C. operation. The results of the South Shore's massive reconstruction were immediate and dramatic.

Passenger revenues began an abrupt increase immediately following the installation of through service into Chicago, and freight revenues continued to grow at a steady rate. For the first time in the railway's history, South Shore's annual operating revenues exceeded a million dollars in 1926. Passenger revenues of over $750,000 represented a 25 percent increase over the preceding year, and freight revenues were up by over 30 percent.

To accommodate the rapid increase in passenger traffic, an order for 20 additional cars was placed with Pullman in January 1927 for delivery the following summer. Ten were equipped as motor cars and ten as trailers. Except for an increase in length to 61 feet, the new cars were mechanically almost identical to the original order. Interior accommodations, however, were substantially improved. Instead of the green plush "walkover" seats installed in the previous equipment, the new cars were fitted with rotating bucket seats upholstered in gray Byzantine plush. In place of the customary smoking section, the cars were provided with an enclosed Pullman type smoking compartment furnished with facing leather covered seats for eight passengers. An aisle passing around the compartment made it unnecessary for passengers entering or leaving the car to pass through the smoking compartment.

Two 53-ton switching locomotives were ordered from Baldwin-Westinghouse at the same time to provide additional motive power for the South Shore's steadily growing freight traffic. Four additional 80-ton locomotives were ordered late in the year for delivery in 1928.

Even before delivery of its new luxury equipment, the South Shore had experimented with the use of rented steam railroad dining cars, with encouraging results. Late in January 1927 the Pullman works delivered the South Shore's own dining and parlor-observation equipment, which represented an investment of almost $200,000 in deluxe passenger service.

Except for their shorter 64-foot length, the four new cars were constructed to typical steam railroad Pullman car dimensions and standards. Weighing almost 57 tons, probably the heaviest non-motored equipment ever operated in interurban service, the cars were mounted on steam railroad type Commonwealth six-wheel trucks, the only equipment of this type ever placed in regular interurban railway service in North America.

The two parlor cars were arranged with a completely enclosed observation solarium and parlor compartment at each end of the car, permitting operation in either direction without turning the cars. The center portion of the car was given over to a women's retiring room outfitted with a small boudoir table and full length mirror, a men's smoking room, toilets, and a small buffet kitchen for light refreshment service. Total seating capacity was 24.

Parlor car passengers were seated in individual arm chairs upholstered in mohair velvet, and a built-in writing desk and magazine table were provided in each parlor compartment. Interiors were finished with walnut woodwork and floors were covered with deep plush carpets. Interior fittings included overhead dome lighting fixtures and bronze side fixtures.

The two dining cars were arranged in the conventional steam railroad manner, with seating capacity for 24 passengers. A green, decorated enamel finish was provided in the dining room, which was also fitted with plush carpeting. The cars were outfitted with handsome tables and chairs and fine linens, china, and silverware. The kitchens were laid out with fast service in mind, in order that short haul passengers would have time to finish their meals.

Arrival of the new equipment was the occasion for an intensive South Shore publicity campaign. On February 10, more than 125 newspaper men, city officials, and other dignitaries from principal South Shore cities were guests of the company on an official inspection tour in the new cars. President Britton I. Budd headed the delegation of company officers that escorted the guests. A few days later the four cars began a six-day exhibition tour of principal on-line cities, during which more than 7,000 persons visited the new equipment.

Regular deluxe limited name train service between Chicago and South Bend began on February 20th, with three dining car and two parlor car trains operating in each direction on 2 hour 30 minute schedules. Eastbound dining car trains, which operated at breakfast, luncheon, and dinner hours, were named the *Notre Dame, Indiana,* and *St. Joe Valley* limiteds, while their westbound counterparts were the *Ft. Dearborn, Illinois,* and *Garden City* limiteds. Eastbound forenoon and afternoon parlor-observation trains were the *Duneland* and *Marquette* limiteds, while their South Bend–Chicago opposites were the *Grant Park* and *Randolph* limiteds.

Parlor car seats were available upon payment of a modest 50 cent charge. A la carte dining car menus offered such items as a "Special South Shore Steak" for $1.25, or a half milk-fed spring chicken for only 90 cents. The dining cars were operated by the South Shore's own commissary, which went to great lengths to assure a high standard of service. In 1928, for example, the railroad purchased 15 prize-winning yearling Hereford steers to be used in serving choice cuts on its dining cars during the Christmas season.

The installation of luxury equipment, as well as such new schedules as the *Chicago Theatre Limited,* which offered fast evening service from Gary tailored to Chicago theater hours, contributed to the increasing popularity of the South Shore's passenger services. Effective with the summer 1927 timetables South Shore increased its schedule to provide 72 daily trains, including 40 limited trains operating over the entire distance between Chicago and South Bend. The South Shore, said *Electric Railway Journal,* "has dealt a smashing blow to competition."

The growth of the railway's passenger traffic was phenomenal. During the first six months of 1927 the South Shore's passenger revenues reached a level of more than double those of the corresponding period only a year before.

In promoting the South Shore's vastly improved passenger service, the railway's Insull management team applied many of the same methods that had proven so successful in the rebuilding of the neighboring North Shore Line.

Soon after the Insull management took charge in 1925, the South Shore entered the bus business, as much to forestall competition as to develop valuable feeders to its rail service. Initially, the railway's bus business—Shore Line Motor Coach Company—operated a service between Michigan City and St. Joseph and Benton Harbor, Michigan. Bus schedules were closely coordinated with those of the railway, and Shore Line coaches used the South Shore terminal in Michigan City. Within the next year Shore Line Motor Coach extended its service to Holland, Muskegon and Grand Rapids, Michigan. Routes were acquired paralleling the South Shore between Chicago, Michigan City, and South Bend. Tickets were good on either buses or trains, but passengers were reminded that the train saved an hour or more. Still other routes were acquired that provided service to points in Illinois

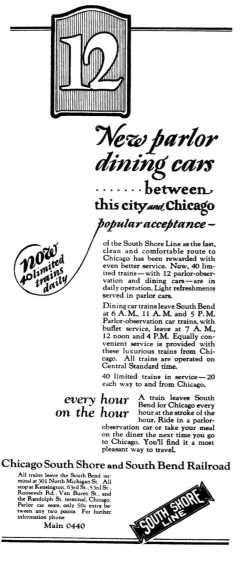

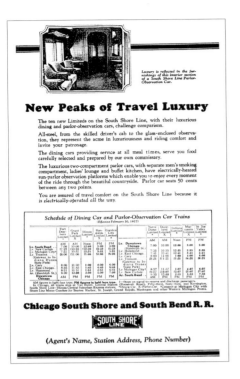
and northwestern Indiana, connecting with South Shore trains at Hammond, East Chicago, and Gary. By the end of 1926 Shore Line Motor Coach was operating a total of 26 routes in Illinois, northern Indiana, and southern Michigan. The company's equipment included the newest type Mack coaches, and for its long distance runs into Michigan, Shore Line purchased the latest A.C.F. "parlor observation coaches," which featured a raised rear section remarkably similar to the Greyhound "Super Scenicruiser" of 30 years later.

In July 1927 the South Shore and Shore Line Motor Coach made a remarkable entry into the long haul passenger trade with the jointly operated *Golden Arrow* service, which ran once daily in each direction between Chicago and Detroit. Eastbound *Golden Arrow* passengers departed from Chicago on the noon dining car train *Indiana Limited* and transferred at South Bend to a non-stop motor coach which made an early evening arrival in Detroit. A similar westbound schedule connected at South Bend with the evening dining car train *Garden City Limited*. The eight and a half hour *Golden Arrow* schedule was said to be fully three hours faster than any other bus service, and nearly as fast as express trains on competing steam railroads.

*Golden Arrow* equipment represented the very last word in 1927 motor coach luxury. The two 25-passenger White model 54 parlor observation coaches procured for the service were provided with inside baggage compartments, toilet and wash room facilities, and a rear smoking and observation compartment. Passengers were seated in individual bucket seats upholstered in blue leather. The coaches were painted blue inside and out, with gold lettering and striping on the exterior. In imitation of steam railroad observation cars, rear ends of the coaches were fitted with a dummy observation platform railing, scalloped awning, and a drumhead sign.

The Insull companies were among the leaders in American industry in such fields as industrial safety, enlightened labor relations, and the development of effective public relations programs. The new South Shore management team brought with it skills in these areas that had already been intensely developed in the exceptionally successful Insull recovery program for the North Shore Line.

Safety was made the subject of intense interest by South Shore management. Safety awareness was encouraged among the railway's employees through such means as regular safety meetings. In 1928, for example, a total of 182 such meetings were attended by over 30,000 employees. Employee safety suggestions were actively solicited, and in 1928 alone 237 such suggestions were placed in effect. Many company employees were trained in first aid, and skilled South Shore first aid teams gave demonstrations for both company employees and the public. Several such teams participated in the Sixth Annual First Aid Championship Meet in Chicago in 1928.

Heroic acts by employees were recognized by such means as presentation of the Britton I. Budd Medal for the Saving of Human Life. Improvements in the railway's signal system and installation of fully protected crossings at many locations contributed to improved operating safety. Typical of the results of the South Shore safety program were those for 1928, when the company experienced a reduction of almost a third in lost-time hours from accidents over the preceding year, despite an increase of over 100,000 hours in total working hours.

In keeping with the advanced labor principles practiced by the Insull companies, the South Shore Line developed a broad program for better employee relations. More than half of the railway's employees took advantage of a group life and accident insurance plan developed by the South Shore, in which the company shared a portion of the cost. A free medical service for employees was established. Employee savings and investment funds were established. A Better Business Cam-

1925

**Duneland**

*Tremont*
THE GATEWAY TO THE DUNES ∾

SOUTH SHORE LINE

paign provided prizes for business tips from employees; in 1927 over 4,000 tips leading to new business were received. Employees were urged to promote the sale of company stock. Over 6,000 shares of South Shore stock were sold in 1928 through the efforts of employees in a customer ownership campaign, and more than 90 percent of the railway's employees bought company stock themselves. A new monthly employee magazine, *The Pantagraph*, regularly included information on the South Shore's current advertising and publicity campaigns, encouraging employee support.

Employee social activities of every description were encouraged. The South Shore organized such events as all-employee parties, and offered a variety of educational and entertainment programs. Under an arrangement with Purdue University, for example, the railway paid half of tuition costs for employees enrolled in night school courses with the University's engineering extension department. A bowling league, a basketball team, and the South Shore Line Men's Chorus were sponsored by the company. Employees trained in public speaking by the railway's Public Speakers Bureau aided the South Shore's promotional program.

The advertising, promotional, and public relations efforts of the new South Shore Line management seemed inexhaustible. A public relations staff issued a continuing series of South Shore news stories to newspapers, magazines, and other publications. A carefully planned advertising program was developed in close coordination with the South Shore's traffic department. Newspaper advertising featured popular events or resorts available by South Shore trains, service changes, special rates, parlor and dining services, or general institutional copy. Freight service was advertised on a national basis. Window displays in principal stations were used to promote special events or attractions along the South Shore. Billboards, electric signs, and posters were used in the railway's outdoor advertising program.

One of the most notable features of the South Shore advertising program was the railway's series of distinguished lithographed posters, which were published regularly for exhibition in company stations, on Chicago "L" platforms, and in schools and libraries in South Shore territory. Designed by prominent Chicago artists, the poster series won wide distinction for its high artistic standards. One, "Homeward Bound by South Shore Line," by artist Oscar Rabe Hanson, won both the Art Directors Club and Baron Collier medals at the sixth annual exhibition of advertising art at the Art Center in New York City in 1927.

Promotional materials printed and distributed by the South Shore included folders, blotters, booklets, and other literature featuring the railway's services or points of interest. An eight-page monthly magazine, *South Shore Lines*, was distributed to the public in trains and stations, or by mail. In addition to traffic promotional material, the magazine included such information as listings of lost and found articles and athletic schedules.

A Public Speaking Bureau organized by the South Shore supplied trained speakers for talks of a public relations nature. A free motion picture library and lecture service was established by the South Shore, and several movies and a series of stereoptican films were produced, covering such varied topics as a history of Chicago area transportation, the Field Museum, the Union Stockyards, vacation areas along the South Shore, and the railway's block signal system.

A miniature South Shore Line working model was built by the railway's electrical department for public exhibit. Operating over a 69-foot track, the highly detailed display included models of the South Shore's freight and passenger equipment, which drew power from an overhead catenary system. At the Greater Gary and East Chicago–Indiana Harbor expositions in 1927, the exhibit drew some 50,000 visitors.

With the North Shore Line and the Chicago, Aurora & Elgin Railroad, which

came under Insull control in 1926, the South Shore opened an Outing and Recreation Bureau and an Own Your Own Home Bureau in Chicago, which provided information concerning points of interest, resorts, vacation spots, and home sites along the three interurbans, and were staffed to assist travelers in making all necessary arrangements. In 1927 some 550 agents of the Chicago Rapid Transit Company and the Illinois Central's suburban service were taken on a day's outing over South Shore's rail and motor coach lines. By gaining firsthand knowledge of South Shore services, reasoned the railway, these men would help sell its services to potential Chicago-area travelers.

Particular effort went into the promotion of traffic to and from the resorts and recreation spots reached by the South Shore. Special party business in particular was vigorously and successfully promoted. In 1928, for example, the railway scheduled some 250 special movements which handled nearly 15,000 persons on picnic outings, lodge specials, church and school parties, and similar excursions. By means of a special arrangement with the Chicago Y.M.C.A. some 1,750 "Y" members were transported to and from a summer camp at Forest Beach on Lake Michigan, moving via South Shore trains between Chicago and Michigan City, with motor coaches of the subsidiary Shore Line Motor Coach Company providing the connection to Forest Beach. To help promote the special travel arrangement the South Shore published a special Forest Beach folder.

Typical of the means employed to promote special movement travel was the publication *Picnic Places Along the South Shore Line,* aimed principally at company picnic committee chairmen, which detailed the attractions of such on-line picnic areas as Hudson Lake, Washington Park, and Grand Beach.

By far the most popular South Shore recreation spot, however, was the famous Indiana Dunes area along Lake Michigan between Gary and Michigan City, and the railway's greatest promotional efforts were directed to the development of traffic to the Dunes. The South Shore worked closely with the Indiana State Park Commission in efforts to protect the Dunes area from industrialization and to establish the 2,000-acre Indiana Dunes State Park. Plans were made to construct a spur track into the park, and the railway contributed $25,000 to a fund for the construction of a resort hotel and bath house in the Park at Waverly.

The attractions of the Dunes Park were regularly featured in South Shore posters, advertising, and promotional literature, such as a special map-folder which showed hiking trails in the Park. Advertising featured the slogan "See the Dunes Afoot" to encourage train riding rather than automobile travel to the Dunes. Special weekend and three-day excursion fares to the Dunes Park were offered.

Construction of what was claimed to be the country's largest structural steel ski slide immediately adjacent to the railway at Ogden Dunes, eight miles east of Gary, gave the South Shore still another recreational attraction. In addition to supporting its construction, the South Shore featured the ski slide extensively in its advertising program, and even built a miniature of the slide which was exhibited at various locations in Chicago.

To supplement the commuter and short haul traffic that constituted the majority of its passenger business, the South Shore Line made a number of innovations intended to encourage the long distance traveler. Through ticketing arrangements were made with the North Shore Line, and for passengers originating on South Shore the railway would obtain railroad and Pullman tickets and even deliver them to the prospective passenger. Arrangements were made with transfer companies to check baggage through to its ultimate destination, or directly to their homes for terminating passengers. A few years later South Shore agents began selling through rail-air tickets via South Shore and the Chicago-based services of United Air Lines, American Airways, and Trans-American Air Lines.

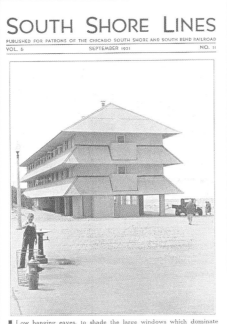

SOUTH SHORE LINES

PUBLISHED FOR PATRONS OF THE CHICAGO SOUTH SHORE AND SOUTH BEND RAILROAD

VOL. 6          SEPTEMBER 1931          NO. 11

■ Low hanging eaves, to shade the large windows which dominate each of the 44 guest rooms in the new state owned hotel, lend a distinctive appearance to the Dunes Arcade which opened for business August 18. It is at Waverly beach (Tremont Station) in the Indiana Dunes State Park.

After the CI&L Railway (Monon Route) discontinued passenger service over its branch into Michigan City in 1928, the South Shore and the Monon developed a through ticketing arrangement between all points in central and southern Indiana. Passengers transferred between trains of the two companies at Hammond, Indiana, where a free taxicab transfer was provided for passengers and baggage.

Even after the initial rehabilitation of the property had been concluded, the South Shore's new Insull management continued to invest substantial capital in a further program of physical improvements which would permit the railway to handle its steadily growing volume of passenger and freight traffic with increased speed and efficiency.

Upgrading of the railway's track structure continued without interruption. By the fall of 1927, barely two years after the new management had assumed control, 70 pound rail had been replaced with 100 pound sections on 30 miles of track. Almost half that mileage had been rock ballasted, and another 2,000 carloads of cinder ballast installed. More than 67,000 creosoted red oak ties had been laid to replace old ties.

In addition to the initial program for double-ended sidings and equipping them with high-speed turnouts to permit high speed meets, key sidings were lengthened to permit greater flexibility in meeting times. The siding at Wilson, Indiana, a principal single track meeting point between Gary and Michigan City, was lengthened to two and one-half miles, permitting a flexibility of six minutes in the meeting time of trains. Another 4,200 foot siding at Tamarack, five miles west of Michigan City, was equipped with No. 20 turnouts and spring switches, which permitted passage of trains at speeds as high as 60 m.p.h. A number of other regular meeting points were also equipped with spring switches, which permitted a meet to be made without stopping to set switches. In order to relieve congestion at Gary, the eastern end of the South Shore's double track installation, an additional 3,300 feet of double track was laid east of the Gary station.

The railway's entire semaphore block signal system, which had been rehabilitated under the initial reconstruction program as an interim measure, was replaced less than two years later with a new Union Switch & Signal Company color light block signal system. A number of special signal installations were made to permit greater speed in the handling of traffic at critical locations. Special signals at gauntlet track installations over bridges on the double track line gave what amounted to automatic interlocking protection, allowing operation of the gauntlets as virtually double track line. Another special installation made in 1928 provided for dispatcher control of the passing track signals at Davis, just east of Michigan City. To assist a late eastbound train to regain schedule, the dispatcher could hold a westbound train at Davis for the eastbound, since a westbound run had a greater opportunity to regain time. Still another special installation at the west end of Gary siding permitted trains to line up a clear route over a main line gauntlet bridge to the west, assuring heavy freights an opportunity to make a run for the grade leading to the bridge.

Late in May 1927 the South Shore opened a handsome new joint rail-bus station at Michigan City, which represented not only a major traffic point on the railway but the principal transfer point between South Shore trains and buses of the subsidiary Shore Line Motor Coach Company as well. Constructed at a cost of over $200,000, the new station included a spacious waiting room with large ticket and information booths for train and bus passengers, a men's smoking room, a "large and artistically furnished" ladies' lounge, a luncheonette counter, and separate parcel and baggage rooms. Doors in the front of the building led to the street where trains stopped to load passengers, while doors in the rear led to the platforms used by buses of the Shore Line company, as well as several independent motor coach lines. The

facade of the station was finished in a handsome buff colored terra cotta, while the interior finish included handsome marble faced columns, and oak trim and waiting benches finished in weathered green.

The second floor of the building contained office spaces for the motor coach company as well as a large meeting hall capable of accommodating 200 persons for employee activities. The basement contained shower and locker facilities for train-men and bus company employees. Adjoining the new station to the east was a new main garage for the Shore Line company. Large enough to accommodate 30 buses, the garage incorporated the latest features and equipment for efficient motor coach maintenance.

Formal opening of the station and garage on Saturday evening, May 21st, was the occasion for gala celebration. To entertain the crowd of over 12,000 people that visited the new facility an orchestra played for dancing in the station proper, while the Chicago Rapid Transit Band gave a concert in the garage. Company officials were on hand to explain the new facilities, and favors were given to all lady visitors.

Although the former South Bend station had been remodeled less than two years before, the South Shore opened a rebuilt and enlarged station at South Bend early in 1928. In order to accommodate the railway's greatly increased passenger traffic, the new facility was more than three times the size of the former station. Architec-tural features of the new terminal were patterned after those of the new Michigan City station. Facilities for beverage and light lunch services, operated by the South Shore, were installed in the new South Bend station as well as several other principal stations.

The South Shore's massive reconstruction program, which by the end of 1927 represented an investment of close to $6.5 million, had enabled the railway to carry out some phenomenal improvements in its services. Passenger service had been increased from a schedule of some 35 daily trains in 1925 to a total of 81 trains by the spring of 1928. An hourly service was offered between Chicago and South Bend from the early morning hours until almost midnight, while half hourly service was operated between Chicago and Gary during the same period. The journey between Chicago and South Bend, which had required a minimum of 2 hours 55 minutes in 1925, was being operated on limited schedules requiring as little as 2 hours 10 minutes by the spring of 1927. Development of additional interchange points with steam railroads, construction of new or enlarged freight stations, and the purchase of new freight locomotives and equipment had permitted an equally significant improvement in the quality of South Shore freight service.

The benefits of the Insull reconstruction program were reflected in glowing statistics in one annual report after another. Passenger traffic increased from a level of little more than a million and a half passengers in 1925 to nearly three million riders annually by 1928, while passenger revenues increased by almost 200 percent during the same three-year period. Freight revenues, which had totaled less than $200,000 in 1925, exceeded a million dollars for the first time in 1928, a three-year increase of some 535 percent. Gross operating revenues, which had totaled slightly under $860,000 in 1925, reached an annual level of well over two million dollars by 1927, and increased again to more than three million dollars in 1928.

It was a time of unparalleled success for the one-time hard luck interurban, and there seemed ample cause for such confident statements as that by South Shore president Britton I. Budd in 1927, "Well located interurban lines, instead of being obsolete, are in reality entering upon the period of their greatest usefulness."

To keep pace with its steadily growing volume of passenger traffic, the South Shore ordered still more new equipment in 1928. Ten steel passenger motor coaches, identical with the Pullman units delivered the year before, were ordered from the Standard Steel Car Company of Hammond, Indiana, in May. A second

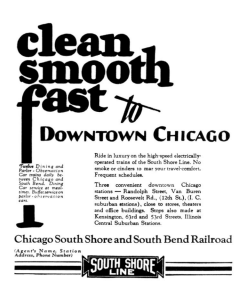

ten-car order placed with Standard six months later included five motor passenger coaches, three coach trailers, and two parlor trailers.

Although the hard work of rebuilding the railroad and developing its traffic to a profitable level characterized the South Shore Line of the late 1920s, there were some lighter moments as well. The South Shore's retired passenger traffic manager, R. E. Jamieson, who joined the railroad in 1926, recently recalled some of them.

Excursion traffic, of course, had always been important to the South Shore. Because extra trains and large crowds were usually involved, things always seemed a little more likely to go wrong whenever special movements were scheduled.

One of the first large special excursions handled by the new South Shore management was the movement of 3,100 students, faculty, and guests from South Bend to Chicago for a Notre Dame–Northwestern football game at Evanston in 1926. The railroad's new equipment had not yet been delivered, and much of its rehabilitation work had yet to be completed. Consequently, the unusually large movement taxed the railroad's facilities to the limit.

The westbound moves were made without mishap, and all went well on the return trip until a special carrying some 500 students arrived at Bendix, just out of South Bend, where it was scheduled to meet a westbound dead-heading equipment run. The westbound train had run into difficulties without ever leaving South Bend, and the student special waited interminably at Bendix. While the dispatcher refused to break the meet the time reached 11 P.M. and then midnight, the Notre Dame deadline for students. Conductor Bob Reppert even offered to walk in front of the train flagging with a red lantern, but the dispatcher was relentless and refused to let the train move. It took most of the night before the mess was straightened out and the special finally crept into South Bend.

The next morning Jamieson appeared before Father Hugh O'Donnell at Notre Dame and took the blame for the railroad to clear the 500 students of rule infractions at the University. During an investigation of the affair at headquarters in Michigan City superintendent Gray asked conductor Reppert, "Did you call the dispatcher?" "Yes, Mr. Gray," chimed in trainmaster Merle Anton, who had listened in on the conductor's calls the night before, "he called him everything."

Typical of the mishaps that could snarl up a special movement was one that occurred during a heavy movement for a Notre Dame–Minnesota football game at South Bend during the 1920s. Five special trains carrying fans to the game became too closely bunched not far from South Bend and blew the circuit breakers in the Grandview Substation. Before the power supply could be restored five trainloads of irate football fans had missed the first quarter.

Things could go wrong on the company's bus subsidiary, too. Passenger man Jamieson recalls one July 4th, when the South Shore promoted an excursion to Detroit, using buses beyond Michigan City. About 2 P.M. one driver called in from Fort Wayne to ask, "How in the hell do I get to Detroit from here?"

One special run that was carried out without any unscheduled mishaps, at least, was what was perhaps the most unusual special train ever handled by the South Shore. Mr. Bendix of the Bendix Corporation at South Bend wanted something different for a sales meeting he was planning, and the South Shore obligingly put together a train of four battered open platform coaches hauled by a borrowed steam engine. A train crew dressed in "Gay '90s" regalia ran the train from the sales meeting in the LaSalle Hotel, through the streets of South Bend, and out to Chain Lakes and return. A news butcher peddled shriveled oranges and old papers and magazines aboard the train. Except for the delay caused by a fake farmer who had tethered his cow along the track, the trip was made without incident except for the fun that Bendix and his salesmen had.

Jamieson still remembers vividly one night in 1931 when he was in charge of a special train transporting the great traction tycoon Samuel Insull himself. Insull had

traveled to South Bend to address the Chicago Club of Notre Dame in a meeting held on the University campus.

The special train, made up of two motor cars and a parlor car, left South Bend on the return trip to Chicago at about 11 P.M. With a clear track, the extra raced toward Chicago at high speed, but Insull was tired and impatient. As the train approached Smith's Hill a few miles east of Hudson Lake at close to 90 m.p.h. a porter summoned Jamieson to the parlor car where Insull was riding.

"Jamieson," said Insull, "can't you make this damn train go any faster?" One never said "No" to Mr. Insull, so Jamieson said, "I'll see what I can do, Sir," and went up to the cab. Jack Teets was the motorman and when Jamieson gave him the "old man's" request, Teets indicated that he had the controller up against the brass and that the train was going better than 85 m.p.h.

Teets, however, was equal to the occasion. He started kicking on about ten pounds of air, then kicking it right off again. As a result, the train developed a pronounced vibration and the speed was reduced about 15 m.p.h. The vibration produced the desired effect, for when Jamieson presented himself to the tycoon, Insull commented, "That's fine, Jamieson."

The advent of the South Shore's heavy, powerful steel passenger cars, as well as the railway's continuing program of improvements to track, passing sidings, and its signalling system, had enabled South Shore to progressively increase its operating speeds from 1926 onward.

Prior to the inauguration of through service into the Chicago Loop over the Illinois Central Suburban electrification in 1926, even the fastest available schedules had required 2 hours 55 minutes for the journey between Chicago and South Bend, with most express schedules requiring three hours or more. Through operation to the Loop with South Shore's new steel equipment permitted substantial improvements in Chicago–South Bend timings. By early 1927 typical limited train schedules called for a 2 hour 30 minute timing, with the railway's fastest train, a late evening South Bend Limited, carded over the line in only 2 hours 10 minutes. Within another year, although the majority of limited schedules remained at 2 hours 30 minutes, a number of the South Shore's extra fast limiteds were being operated on 2 hours 15 minutes timings. Still another tightening of schedules in the fall of 1928 reduced the standard limited train timing to 2 hours 20 minutes between Chicago and South Bend, with extra fast trains operating on 2 hour 5 minute timings.

Ever since the private automobile had begun to represent a growing threat to interurban railway passenger traffic in the years following World War I, an increasing number of leaders in the traction industry had come to regard high speed service as one of the most important measures by which they could maintain a competitive edge over highway travel. Foremost among the advocates of high speed operation during the early 1920s were the editors of *Electric Traction* magazine, one of the two leading industry trade journals. Speed, editorialized *Electric Traction*, was the primary factor in the public's choice of travel mode. Comfort, luxury, and even safety were of secondary consideration.

Even as early as 1924, a year before the railway's reorganization and reconstruction under Insull management, the South Shore's fastest Kensington–South Bend timings gave the railway a respectable seventh place ranking in a national interurban speed tabulation compiled by *Electric Traction*. By 1927, after the inauguration of through service into Chicago with its new equipment, the South Shore's 2 hour 10 minute fastest timing between Chicago and South Bend had gained the railway a national speed ranking second only to the North Shore in what had become an annual interurban speed contest sponsored jointly by *Electric Traction* and the American Electric Railway Association.

The South Shore's speed contest ranking remained unchanged the following

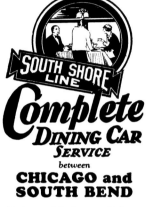

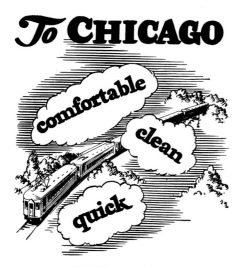

year, but in 1929 a further acceleration of its fastest Chicago–South Bend timing to two hours flat enabled the railway to take possession of the handsome silver *Electric Traction* interurban speed trophy from the North Shore Line, which had held it for the two previous years. The South Shore's contest-winning 45 m.p.h. terminal-to-terminal average speed represented an increase of no less than 33 percent in the average speed of the railway's fastest schedules within a period of only three years.

An even more prestigious award for the South Shore in 1929 was the railway's selection as the seventh annual recipient of the Charles A. Coffin prize. The Coffin award was provided by the Charles A. Coffin Foundation, which had been established in 1922 by the board of directors of the General Electric Company in honor of the company's first and long-time president. The annual prize, which included presentation of the Charles A. Coffin Gold Medal to the company and a gift of $1,000 to its employees' benefit or a similar fund, was awarded by a committee of the American Electric Railway Association "to that electric railway company in the United States which during the year has made the greatest contribution toward increasing the advantage of electric transportation for the convenience and well-being of the public and for the benefit of the industry."

Selection of the South Shore for the award was made by the AERA's 1929 Coffin Prize committee after reviewing the phenomenal improvements in service and operating results brought about by the Insull reconstruction program. "Within four years the Chicago South Shore and South Bend Railroad,—" noted the committee, "has moved figuratively from the scrap heap to the front rank among the electric railways of America."

Both the speed trophy and the Coffin Prize were presented to the South Shore at the October 1929 annual convention of the American Electric Railway Association in Atlantic City. The South Shore's efficient publicity organization made the most of the dual presentation. Impressive six-column advertisements in Chicago and northern Indiana newspapers featured the two awards and depicted the services that had won them. Articles about the awards were featured in *South Shore Lines* and *The Pantagraph*, the railway's monthly magazines distributed to the public and employees. A handsome booklet, *First and Fastest*, was printed for wide public distribution. In the Chicago area South Shore joined with the two other major Insull interurbans, the North Shore Line and the Chicago, Aurora & Elgin Railroad, in an extensive billboard, poster, and card advertising campaign on the Chicago "L" and surface car systems, as well as newspaper advertising, featuring the fact that the three roads had captured the first three places in the 1929 *Electric Traction* national interurban speed contest.

Receipt of the two distinguished industry awards highlighted what was to prove one of the greatest years in the entire history of the South Shore Line. Traffic and revenues for 1929 increased again over even the remarkable level of 1928. Passenger traffic reached a new peak of almost three and a quarter million passengers, and passenger revenues passed the two million dollar level for the first time. Freight revenues of nearly $1.6 million represented an increase of close to 30 percent over the previous year. Gross operating revenues for the year were almost $3.7 million, an increase of some 330 percent over the 1925 level.

If 1929 seemed the best of all possible years for the South Shore, disturbing doubts for the future were raised by the catastrophic events in the New York stock market late in the year.

The effects of the great Wall Street crash of 1929 and the great national depression that followed it were by no means immediately felt by the South Shore Line. Although the exhilarating increases of the previous five years failed to continue, operating results for 1930 were only slightly off the record level of 1929. Passenger traffic dropped off to a level of three million passengers, but the decline in revenues

was at least partially offset by a modest increase in freight revenues over those for the previous year. Gross operating revenues for the year remained above $3.5 million, and net income was down by only a little over $100,000.

Still optimistic for the future, the South Shore continued to undertake major improvements to the property during 1930. A large new shop building of some 32,000 square feet, including the latest available equipment for heavy rolling stock repair and overhaul, was placed under construction at Michigan City. The original shop building, which had served the South Shore since its opening in 1908, was rebuilt for use as an inspection and painting facility. Confident of continuing traffic growth, South Shore built a facility that could adequately care for a much larger fleet of cars and locomotives.

A new freight terminal was placed under construction at South Bend. Three 85-ton freight locomotives were ordered from the General Electric Company, and another 80-ton Baldwin-Westinghouse unit was ordered for delivery in 1931.

By 1931, however, there was no longer any doubt about the effect of Depression conditions on the South Shore. Passenger traffic fell abruptly to a level of some 2.2 million passengers, the lowest since 1926. Freight revenues dropped below the $1.5 million level for the first time since 1928. Gross operating revenues for the year were down to $2.9 million. Even at that, the South Shore managed to post a modest net income of $115,000.

If 1931 was bad, 1932 was a disaster. Passenger traffic plummeted downward again to less than 1.5 million, the lowest level since the earliest years of the predecessor Chicago, Lake Shore & South Bend Ry. Freight revenues declined almost as severely, to less than a million dollars. Gross operating revenues for the year were less than $1.9 million, and the South Shore posted a 1932 net loss of almost half a million dollars.

Despite its rapidly declining fortunes, the South Shore continued to maintain a high standard of service. In 1930 the railway cut its fastest Chicago–South Bend timing to a new low of 1 hour 58 minutes, and retained the *Electric Traction* speed trophy for a second year. Even though the North Shore Line regained possession of the trophy in 1933 with even greater accelerations, the South Shore continued to improve its high speed performance during the early Depression years. In 1931 another five minutes was cut from the fastest schedules, to give the South Shore an average schedule speed of almost 48 m.p.h. over the 90-mile Chicago–South Bend run. By 1933 the best timing had been cut to only 1 hour 50 minutes, a terminal-to-terminal average of over 49 m.p.h.

Even into early 1932 the South Shore continued to schedule no less than 80 daily trains, 11 of which offered dining or parlor car service. The only apparent concessions to Depression conditions were the $1 luncheons and $1.50 dinners offered on dining car menus.

But by the spring of 1932 Depression realities could no longer be avoided. Drastic cuts in passenger service were ordered, and dining and parlor car service vanished from South Shore timetables for good. The once expansive operations of the South Shore's motor coach subsidiary, which had been merged into the railway in 1930, suffered even more drastically. By 1932 motor coach services had been reduced to only four daily round trips over a single route between Michigan City and Benton Harbor, Michigan.

Operating results for 1933 were even worse than the preceding year. While passenger traffic remained almost at the 1932 level, freight revenues declined to a new low of barely $800,000. Although gross operating revenues were down to less than $1.7 million, reductions in operating costs held the net loss for the year to less than $360,000.

The great Insull public utilities empire survived the first few years of the Depres-

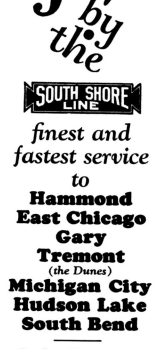

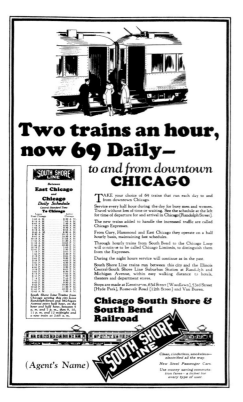
sion without difficulty. But a financial crisis in 1932 forced one of the keystones of the Insull empire, Middle West Utilities, into bankruptcy. Soon afterward, Sam Insull was forced out of the management of his remaining interests, and the great Insull utilities empire collapsed. The South Shore, with the heavy losses of 1932 and 1933, proved no less vulnerable than the remainder of the Insull empire.

Dividends had never been paid on South Shore common stock, and early in 1932 dividends were suspended even on the railway's preferred stock. On September 30, 1933, the South Shore entered bankruptcy.

Once again the South Shore Line had hit bottom in the roller coaster course of its corporate fortunes. The exhilarating years of the Insull era were past, and the business at hand was now that of survival itself.

# NOT JUST SELLING RAILROAD TICKETS

## THE ROLE OF THE SOUTH SHORE LINE POSTER ART IN THE DEVELOPMENT OF NORTHWEST INDIANA

Bob Harris

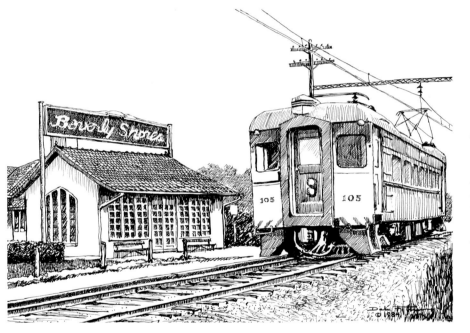

*Beverly Shores,*
Dale Fleming, 1984.

The decade of the 1920s was the zenith of the age of selling. Commercialism was at a peak, but so was scorn for advertising men. America's authors, expatriate and home-bound alike, such as Ernest Hemingway, F. Scott Fitzgerald, and Sinclair Lewis, bemoaned the loss of regional diversity through the selling of "motorcars and Ivory soap and ready-to-wear clothes" (Cowley, 1951). Although the poster art commissioned by the Chicago South Shore and South Bend Railroad (South Shore Line) was created to fulfill a commercial mission, its commercial character should not diminish its splendor. The beauty of the poster images reflects the beauty of their diverse subjects: primarily the natural playground of the Indiana Dunes and the industrial center of the Workshop of America. The management of the South Shore Line understood that the diversity of Northwest Indiana played an important role in the success of the railroad. Through the beautiful images of the poster art, the South Shore Line met its commercial objective, as stated by General Manager C. H. Jones in 1927, "to create business where it did not exist by selling the territory served to those living outside of it."

Samuel Insull's Midland Utilities Company believed that it could create business

through suburban development by providing superior electric transportation. To that end, by 1926 Insull had acquired the South Shore Line as well as the other two heavy-duty interurban railroads radiating from Chicago, the Chicago North Shore and Milwaukee (North Shore Line) and the Chicago Aurora and Elgin. Insull's investment in interurban railroads appeared to be ill-timed. Not only did Insull underestimate the impact of the automobile on railroad ridership, he could not foresee the Depression and its impact on land development. As the economy continued to thrive, however, the Insull-owned interurban railroads jointly created the Outing and Recreation and Own Your Own Home bureaus on June 27, 1927. Supporting the work of the bureaus, the previously launched poster campaign was more than just a colorful footnote in the history of Insull's interurban railroads. Through the poster art, Insull hoped to develop Northwest Indiana.

Before the Insull management took charge of the South Shore Line, little effort was made to coordinate the development of the railway with the economic development of the Region. Any effort that might have been made was hampered by the poor financial performance of the South Shore Line's predecessor, the Chicago Lake Shore and South Bend Railway. The Chicago Lake Shore and South Bend did play some role in developing Northwest Indiana, however, by providing excursions to the Dunes for the Prairie Club of Chicago. Indiana Dunes historian J. Ronald Engel credits the completion of the Chicago Lake Shore and South Bend Railway in 1908 as being "perhaps the most important of all . . . in [rapidly increasing] interest in the dunes among artists and writers." Spurred by the access to the Dunes created by the Chicago Lake Shore and South Bend Railway, the Prairie Club and National Dunes Park Association began a lobbying effort, resulting in the establishment of the Indiana Dunes State Park in 1925.

After the Chicago Lake Shore and South Bend Railway was sold to Midland Utilities in 1925, both Insull and the South Shore Line supported the development of the Indiana Dunes State Park. The South Shore Line planned a spur line into the state park with "a rail terminal at the park entrance adjacent to a proposed hotel, bathing facilities, pier and dance pavilion." Construction of the hotel and bathhouse at the Indiana Dunes State Park was later assisted with a $25,000 gift from the railroad. Further, Insull personally assisted the state park development effort with a $200,000 loan to the Dunes Park Purchasing Board and a donation of land for the park entrance. The rail spur was never built, but its proposed alignment is now the extension of Indiana State Road 49 into the state park.

The South Shore Line was the only railroad serving the Dunes east of what was then called Dune Park (where Bethlehem Steel located in 1964), and the railroad took full advantage of it. The South Shore Line publicity department described its Dunes promotional efforts as having "exploited [the Dunes] to a great degree." The Outing and Recreation Bureau's Dunes promotional campaign included newspaper advertising trumpeting the Dunes as the place "Where Wilderness is King," pamphlets stressing that Duneland is "Chicago's favorite playground," and trail guides of the State Park that described "The Dunes—What they are—What to do there— And how to reach them conveniently and safely." It is no coincidence that twenty-three of the thirty-eight known surviving South Shore Line posters feature recreation in the Dunes.

Immediately east of the state park were the subdivisions of the Fred'k H. Bartlett Realty Co.: Beverly Shores, Lake Shore, North Shore Beach, and South Shore Acres, the largest lakefront development ever in Chicagoland. Once the South Shore Line had introduced visitors to the beauty of the Indiana Dunes, perhaps they would like to have a piece of the wilderness all to themselves—Chicago's Largest Real Estate Operator could get it for them. And once they have built their suburban dream homes among the dunes, they could conveniently travel to down-

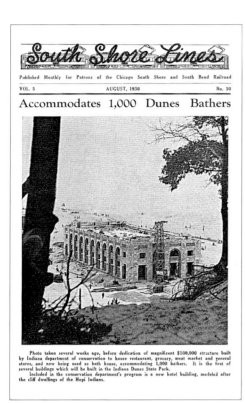

*South Shore Lines*

Published Monthly for Patrons of the Chicago South Shore and South Bend Railroad

VOL. 5          AUGUST, 1930          No. 10

Accommodates 1,000 Dunes Bathers

Photo taken several weeks ago, before dedication of magnificent $100,000 structure built by Indiana department of conservation to house restaurant, grocery, meat market and general stores, and now being used as bath house, accommodating 1,000 bathers. It is the first of several buildings which will be built in the Indiana Dunes State Park.
Included in the conservation department's program is a new hotel building, modeled after the cliff dwellings of the Hopi Indians.

town Chicago from one of two new $15,000 South Shore Line stations. Their ride would be aboard modern "electrically-operated trains [that] embody all the refinements and comforts of steam railroad Pullman car travel—without the un-pleasant dirt, dust and cinders," as the advertising explained. Clearly the South Shore Line wanted Chicagoans to see the Dunes through the posters, come to Indiana for recreation, and then build their suburban homes and stay. In theory, through the medium of the posters, the promotional campaign of the Outing and Recreation Bureau and the Own Your Own Home Bureau could transform an occasional rider out to tour the Dunes into a regular commuter.

It is difficult to determine which South Shore Line posters, if any, supported the work of the Own Your Own Home Bureau. Perhaps *Homeward Bound* (p. 69) and *Outward Bound* (p. 119) did so in an abstract sense. It is impossible to tell what other poster images now no longer exist, but it is likely that perhaps eighteen or more posters simply have not survived. Since a new South Shore Line poster was released each month, and there are only eight known posters for 1925, eight for 1926, twelve for 1927, and five each for 1928 and 1929, it appears that quite a few images are missing. Plus, it is not known when the poster campaign began and ended. Could there be more posters from 1925, or even some produced in 1930 before the full effects of the Depression were felt at the Insull companies? Is it possible that there were posters celebrating suburban development in the Dunes?

To get a sense of what might be missing from the South Shore Line poster images, compare and contrast them with the posters of the North Shore Line. Both of Insull's interurban railroads had posters promoting recreational activities and sites. Examples of North Shore Line recreational posters include hiking and hunt-ing; South Shore Line recreational posters promoted visits to the Dunes beaches, Hudson Lake, and winter sports. Events featured in the North Shore Line posters

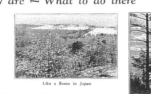

include summer opera at the railroad-owned Ravinia Park and a horse show at Fort Sheridan; events promoted by the South Shore Line posters include a ski meet at Ogden Dunes and Notre Dame football games. Both the North Shore Line and the South Shore Line had posters featuring the seasons. The North Shore Line had several posters promoting suburban development in the Skokie Valley that blatantly supported the work of the Own Your Own Home Bureau, including images titled *Suburban Communities* and *Where Homes are Homes* (p. 25). Suburban development at Beverly Shores was likely as important in developing South Shore Line ridership as suburban development in the Skokie Valley was to developing North Shore Line ridership. Therefore, it is possible that there were South Shore Line posters that no longer exist but were similar to the North Shore Line image titled *Where Homes are Homes* that directly supported the campaign of the Own Your Own Home Bureau.

But more important to the survival of the South Shore Line than the development of Chicago's Indiana suburbs was the development of The Workshop of America. At least three posters highlighted the steel mills and industry of Chicago's industrial heart, the Calumet Region. The importance of the development of industry along the South Shore Line cannot be overemphasized. The failure of the Chicago Lake Shore and South Bend Railway to develop significant freight traffic was one of the reasons it was in bankruptcy when Insull purchased it. Freight traffic development was the area of greatest promise on the South Shore Line, just as freight traffic had become vital to salvaging what little remained of the interurban railway industry generally.

As one of the South Shore Line posters is titled *Visit "The Workshop of America"* (p. 67), it is difficult to discern whether the posters with industrial themes supported travel to the industrial areas along the railway or were intended to stimulate further industrial development and freight traffic in the same way that the *Suburban Communities* posters were expected to stimulate residential development. If posters hung at "L" station platforms seem to be an unusual way to showcase the industrial development potential along the South Shore Line, consider that the automobile had not made significant inroads into North Shore Line and Chicago "L" ridership until after 1926. Since Insull's Chicago Aurora and Elgin; North Shore Line; and Chicago Rapid Transit all operated on the "L" and served suburban areas filled with executive homes, it is possible that corporate decision-makers would have been exposed to the South Shore Line poster images in their daily commuting. These factors may have prompted the Insull management to view public transit as an appropriate venue for promoting industrial development as well as recreation and suburban home ownership. Although the role of the posters with industrial themes in promoting industrial development along the South Shore Line may be questioned, there can be no doubt about the results of the South Shore Line's efforts. During the poster campaign, the South Shore Line worked closely with the Chambers of Commerce of the cities along the railroad to promote industrial development in Northwest Indiana. As a result, by 1929 fifteen new industries were being served by the South Shore Line.

In 1929, the South Shore Line won the Charles A. Coffin Prize of the General Electric Company, awarded annually to "that electric railway which, during the year, had made a distinguished contribution toward the development of electric railway transportation for the convenience of the public and the benefit of the industry." In announcing its successful submission to the *Electric Railway Journal,* the South Shore Line credited its success to progressive merchandising methods, including "posters artistically depicting the natural beauties along its right-of-way." No other method of progressive merchandising was mentioned in the published copy. Clearly, the management of the South Shore Line believed that the posters had become an

*Where Homes Are Homes,*
Charles B. Medin,
1929 (lithograph).
Calumet Regional Archives,
Indiana University Northwest.

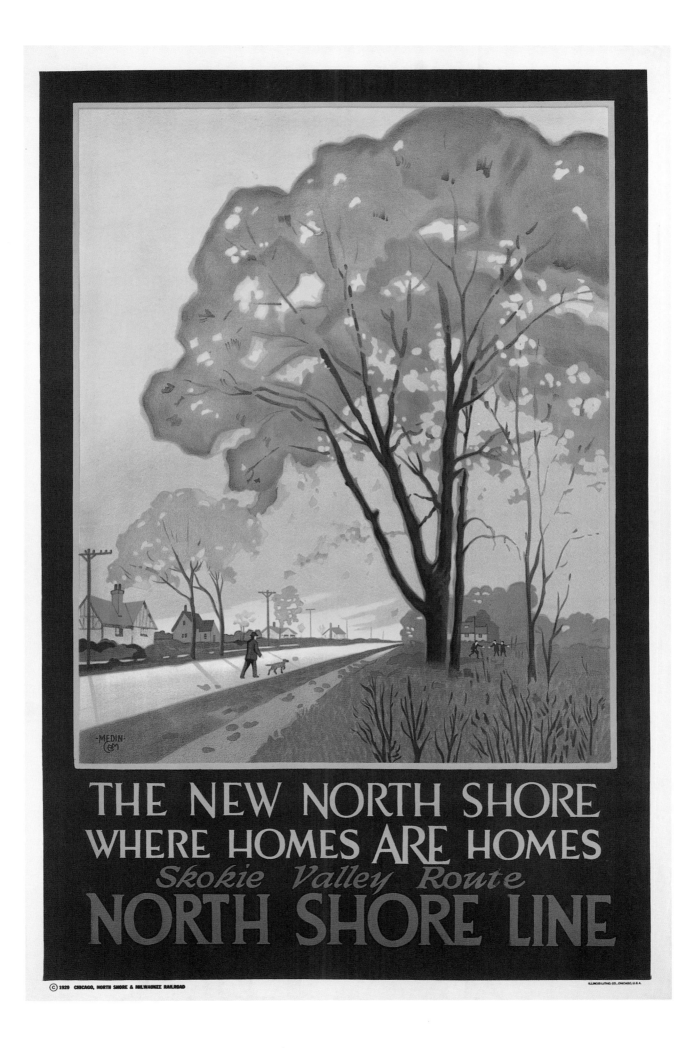

important part of the campaign to develop both freight and passenger traffic through the development of Northwest Indiana's industrial and residential potential.

## SOURCES

"Chicago South Shore and South Bend Railroad." Brief submitted in competition for the fifth annual award of the Charles A. Coffin Foundation. Michigan City, Ind., 1927.

"Chicago South Shore and South Bend Railroad." *Timetables.* Chicago: Poole Bros., April 28, 1929.

"Coffin Award Won by South Shore Line." *Electric Railway Journal* 72 (1929): 975–976.

Cowley, M. *Exile's Return: A Literary Odyssey of the 1920s.* New York: Viking Penguin, 1951.

Engel, J. Ronald. *Sacred Sands: The Struggle for Community in the Indiana Dunes.* Middletown, Conn.: Wesleyan University Press, 1983.

Franklin, Kay and Norma Schaeffer. *Duel for the Dunes: Land Use Conflict on the Shores of Lake Michigan.* Urbana: University of Illinois Press, 1983.

Hilton, G. W. and J. F. Due. *The Electric Interurban Railways in America.* Stanford: Stanford University Press, 1960.

Jones, C. H. "Heavy Interurban Meets the Urge of Automobile Competition." *Electric Railway Journal* 70 (1927): 496–498.

Middleton, William. D. *North Shore: America's Fastest Interurban.* San Marino, Cal.: Golden West, 1964.

————. *South Shore: The Last Interurban.* San Marino, Cal.: Golden West, 1970.

Moffat, B.G. *The "L": The Development of Chicago's Rapid Transit System, 1888–1932.* Chicago: Central Electric Railfans' Association, 1995.

"New Suburb in the Dunes." *The Economist,* May 7, 1927.

"Rehabilitation Brings Results on the South Shore Line." *Electric Railway Journal* 70 (1927): 852–856.

# COMMERCIAL ILLUSTRATION, POSTER PAINTERS, RAILWAY MEN

Mitchell A. Markovitz

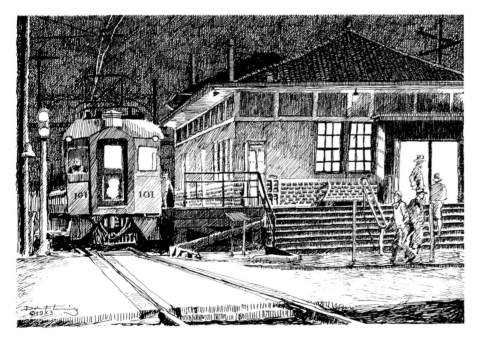

*Gary, at Night,*
Dale Fleming, 1983.

The art that we enjoy on the South Shore Line posters belongs to a craft known as commercial illustration. Norman Rockwell referred to the time between 1890 and 1920 as the "Golden Age of Illustration." That was the time when fabulous painters turned their talents to depicting scenes and objects to sell products. All advertising of the era came from commercial art studios.

The duties of commercial artists went beyond illustration. An artist needed knowledge of drawing, design, layout, lettering, typography, key line and paste up, and of course rendering and illustration. After graduating from high school, a prospective artist would spend from two to four years at an art academy. The student would learn how to draw in perspective, construct shadows, work with color, and spend hours learning how to draw the human figure. After completing school, the artist hoped to secure a job as an apprentice in a studio. The young apprentice was expected to arrive on time, wearing business attire. An apprentice's duties included answering the phones, running errands, ordering supplies, cutting art boards and mats, ordering type, pasting up type, and spending time with ruling pen in hand

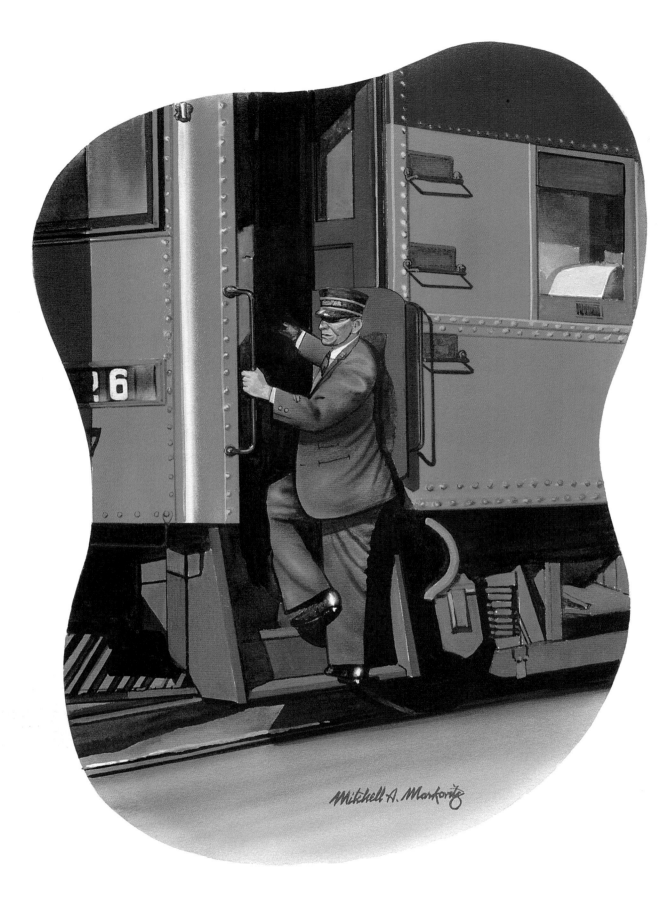

*Conductor Boarding Train at East Chicago, 1929,*
Mitchell A. Markovitz, 1997.

making various borders for ads. Apprentices could also lay out colors and brushes for their employer. Gradually, an apprentice would take on more responsibilities as a full illustrator.

The studio, however, was not a place of complete reverence and order. When creative souls got together, something besides great art was likely to happen, as exemplified in this story from my father. Pop was a commercial illustrator and tells of a studio-style practical joke. He worked in a studio in Chicago, north of the loop at Michigan and Ohio Streets and shared his work space with several other commercial art men. One cool and rainy March afternoon the light of humor came to one of the artists. They snatched the galoshes belonging to one of the other associates, and with enamel they carefully painted big ugly feet on them, complete with bloody toe nails. When the enamel dried, they carefully airbrushed dull black water color on the boots and put them back near the coat rack. Later that afternoon the poor victim put on his raincoat and rubbers and headed for the Randolph Street Illinois Central station. He noticed folks pointing and laughing at him. The rain had washed the black paint off the boots, revealing those silly painted feet.

The artists who created the South Shore Line posters had to have yet another special skill: working with the lithography process. The artist would produce a painting, then each color area would be outlined, and traced onto a separate litho stone. The artist would render the areas to be colored with a greasy litho crayon. What was rendered held the colored ink as the stone went through the press.

Poster art is nothing more than well done merchandise labels on a grand scale— visuals that tell and sell in an instant. The South Shore Line posters are the best of the best in advertising from an age that only knew superlatives. Their creators were great commercial artists. Except for those artists who won awards, or went on to become fine artists, little is known or has been written about them.

Ivan Beard had a studio in downtown Chicago. Oscar Rabe Hanson's poster work won awards in 1925, but he died before he could receive them. Otto Brenneman was a World War I hero of the German army in eastern Europe. My favorite artist was Leslie Ragan. He was raised in Iowa and began his art education there. Ragan was a fighter pilot in the air corps during World War I. This explains his use of fantastic clouds and skies in his work. He had a studio in Chicago for some time before moving on to New York, California, and Europe. His works, both poster and illustration, were more painter-like than most advertisements. His work took average vistas into a Maxfield Parrish fantasy land. He had a great love of transportation and travel subjects. Ragan died in 1972.

In their posters, all of these artists display a fabulous, scholarly, classic approach to drawing and color usage. Their works feature a general, overall color scheme. The vignettes themselves are wonderfully simple and believable vistas. Hanson's *Autumn in the Dunes* (p. 45) offers a warm red-orange scheme, setting the fall tone. The horse and wagon and driver are well-drawn. The dunes have a gentle roll out to the lake. The lighting, though, is magical. It must be about 4:10 P.M. on a Sunday afternoon in October. All of the bright warmth is set off by the cold dark blue of the lake and sky. The colors give the viewer a feeling of approaching cold. *Visit "The Workshop of America"* (p. 67), by Brenneman, is a beautiful, factual fantasy. The two figures offer a brilliant example of figurative drawing. The layout is simple, with strong colors. Ivan Beard's *Autumn in the Dunes* (p. 101) takes full advantage of a traditional poster technique. The colors are all flat, distinct "nations of color," and there is no subtle shading. The modeling in the drawing is achieved simply by colored shapes. Leslie Ragan's *Indiana Dunes State Park* (p. 85) exhibits his expert and artistic treatment of skies—colorful, bubbly clouds float across the summer sky. The dunescape is just as fluid. The view itself, placing the observer up to his or her neck in lake water, underscores his sense of humor.

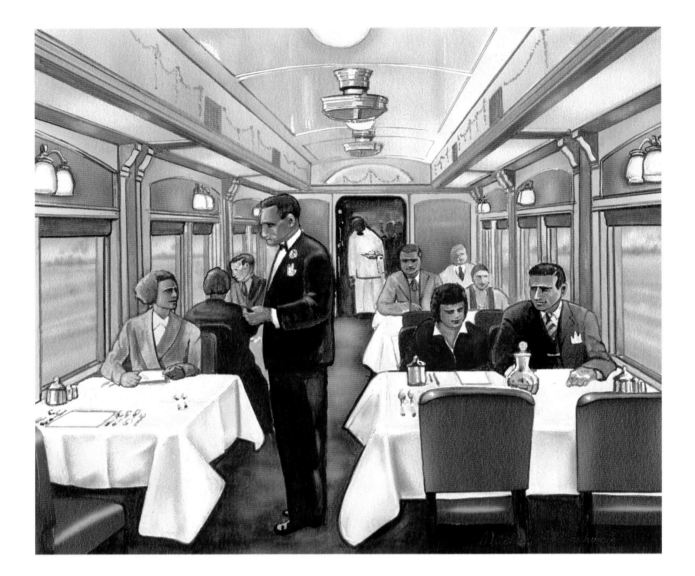

*Dining Car, South Shore Line, 1929,*
Mitchell A. Markovitz, 1997.

There's another poster artist that I'd like to mention, a contemporary painter closely associated with the South Shore Line. That artist is me, and I'd like to share with you a little bit about my combined career of art, illustration, and railroading. I was born in 1950 on the south side of Chicago. My father's list of commercial art clients included the Illinois Central Railroad. From my earliest recollection, Pop would come home from the studio and teach me how to draw. Our neighborhood was laced with railroads that caught my eye, and Pop taught me how to draw trains. The Illinois Central on the South Side was referred to as the "IC." When I started school we would sing "My country 'tis of thee, Sweet land of liberty," followed by what I thought was "Of thee IC!" My, those trains were important. I spent my entire public school life drawing trains. Our family summers were filled with the dunes and Michigan City. My scout troop camped in the Indiana Dunes State Park. The scouts would go hiking, and I'd disappear to the Tremont South Shore Station. I'd force Pop to chase South Shore trains down 11th Street in Michigan City.

By the time I entered Bowen High School I was already winning awards with my art. For my 15th birthday my grandmother presented me with a railroad watch. Art achievements or not, I made my career choice: I'd be a railroader. During my high

*Michigan City Depot at Night, 1929,*
Mitchell A. Markovitz, 1997.

school summers, I worked as an apprentice in my father's studio. I learned commercial art the old-fashioned way. I completed my first commissions when I was 16. After high school I attended the American Academy of Art, a very conservative institution in 1968—no moustaches, no blue jeans. Just hard work, the old-fashioned way. By the time I completed my first year of school, my urge to go railroading and grow a moustache overcame me, and off I went.

I worked on two railroads before I arrived on the South Shore Line. The railroads

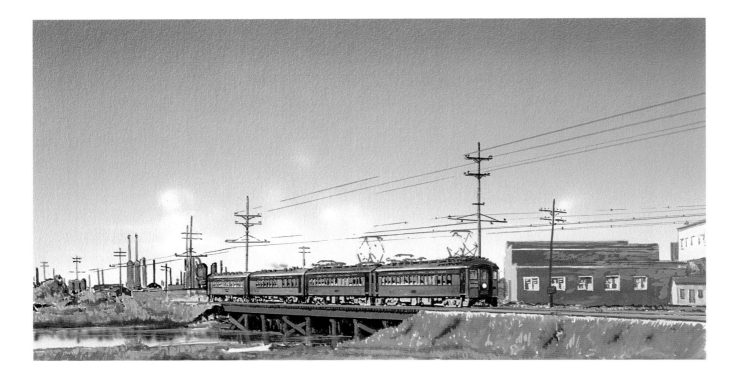

*South Shore Line's Indiana Limited,*
*Crossing Calumet River, Heading*
*for South Bend, 1929,*
Mitchell A. Markovitz, 1997.

paid well and I had plenty of time to develop as a painter. In the early 1980s, during downsizing, I left railroading and began painting and teaching full time. I entered shows. I won awards. I went to New York, and I joined professional art societies. In 1983, I created my first South Shore poster *Faithful Service* (p. 121). It honored the retirement of the Line's original orange cars. When the management of the South Shore changed in 1984, I was asked to be art and creative director. I held that position for a few years until some strong commissions came my way. I kept the railroad as a client and went independent—but, a miracle happened. The South Shore Line became short of trainmen, and I was becoming nostalgic for my railroad life. So I worked as a collector for a few months right before my first one-man exhibition in New York. Back to an artist's life I went when the manpower shortage on the South Shore was over. I started to conduct seminars on pastels and color usage. I had more shows in New York. I grew a big long pony tail.

During the first part of 1990 the art market went a little soft and the South Shore Line needed trainmen again. Being a practical guy and having an investment in a railroad pension (and searching for affordable insurance), I came back home to the South Shore Line, where I remain as a trainman, engineer, and art coordinator. My career is a blessing, and I feel privileged to serve the northwest Indiana community.

I operate the trains that I love, for folks whose company I enjoy, through a region so dear to me that I create art to express myself. From my engineer's window every morning I see Oscar Rabe Hanson's geese fly across Ragan's sky, through Ivan Beard's dunes, past Otto Brennemann's Workshop of America. My card reads: Mitchell A. Markovitz: Artist-Illustrator-Railwayman.

# SOUTH SHORE RECREATION
## A FUN WAY TO SAVE A RAILROAD

John Paul Laue

*Little Train That Could,*
Dale Fleming, ca. 1973.

Like most Northwest Indiana residents, I had always taken the South Shore Line for granted. My father had commuted to work on the train since I was a little kid in the 1950s, and I rode it occasionally to baseball games and other special events in Chicago. Moving back to the Calumet Region during the summer of 1976, after living and working for several years in Micronesia, I rented a friend's rustic lakefront cottage in Beverly Shores. There I planned to write a book about some of my experiences in the South Pacific. I loved being back in the dunes, running on the beach and listening to the waves lapping at the shoreline outside my window. It felt good to return, with plenty of time to write and reflect about what I wanted to do with the rest of my life.

Having grown up in the sixties, I was still very much into causes, and there was no shortage of them in the Region. When I first returned, the issue I cared about the most was saving the dunes, particularly the area where I grew up. I closely followed the progress of legislation that was being debated in Congress to expand the boundaries of the Indiana Dunes National Lakeshore. I began to regularly attend meetings of the Save The Dunes Council, which was spearheading the expansion effort. As the debate in Congress heated up, the Council asked for volunteers willing to spend some time in Washington to lobby for the bill. I jumped at the chance.

Shortly before the Senate finally passed the expansion bill in October, I returned to my lakefront cottage and tried to get back to my writing. But once again, I found it difficult to adjust to the solitude and discipline that serious writing requires. I had enjoyed my first taste of region-style political activism, and wanted some more. My next opportunity came later that fall when the South Shore Line announced its intention to abandon passenger service.

News of the proposed abandonment disturbed me. Since my return to the Region, I had started to use the train more often, and began to genuinely treasure it. I enjoyed boarding at the quaint Beverly Shores station, then watching the juxtaposition of nature, industry, and decaying urban landscape rush by on the trip into Chicago. During this period of occasional riding, I also began to appreciate the comfort and charm of the old South Shore cars, particularly the original ones built by Pullman in 1926. These cars had comfortable bucket seats, ornate domed lights, mahogany woodwork, and windows that could actually be opened and closed. The beauty and style of these cars was in stark contrast to the other cars in the fleet, which had been lengthened and modernized during World War II, with harsh neon lights, uncomfortable seats, and large picture windows that could not be opened and were usually so dirty that you couldn't see out of them.

That fall, someone had given me a copy of Bill Middleton's history, *South Shore: The Last Interurban*. This fascinating account opened my eyes to the railroad's historic significance to the Region and the critical transportation role that interurban systems played in this country during the early part of the twentieth century. By the time of World War I the system had reached its peak, with over 70,000 interurban cars in daily operation around the country. The fact that the South Shore was the sole survivor of this vast interurban network made me appreciate it even more. This book was also my first exposure to the beautiful South Shore Line posters that Samuel Insull had commissioned during the late 1920s to promote the railroad and the attractions along its right-of-way.

In early December, I read in the paper that the Interstate Commerce Commission was scheduling a series of public hearings to provide opportunities for public comment about the South Shore's proposed abandonment. I decided to attend one of the hearings in Valparaiso, and there I heard a parade of politicians and a few citizen activists make heartfelt speeches about the importance of keeping the service alive. A handful of commuters who could afford to take a day off work also came to tell the commissioners how they depended on the train to get to and from their jobs in Chicago. I watched these proceedings with great interest, and felt myself being drawn to another cause.

At the time, the South Shore was still carrying several thousand weekday commuters, including my father, and most elected officials realized that it was important to retain the service. But these politicians were less than enthusiastic about the possibility of spending public funds to attain this goal. Many of them found it hard to understand why a profitable railroad, with a healthy freight business, should require government money to support its passenger service. Because of this lack of enthusiasm about spending taxpayer dollars to subsidize a private railroad, there was clearly a need for more public involvement if the passenger service was going to be saved. An ad-hoc group of commuters, calling themselves Save the South Shore, had begun meeting regularly in Michigan City. Meanwhile, another group was being formed in Chicago with similar goals but a different focus.

Two dynamic women founded this group, Lois Weisberg and Lee Botts. Both were very involved in Chicago politics and civic affairs, and both had summer cottages in the dunes. Lois and Lee were politically savvy and very adept at getting lots of positive publicity for their favorite causes. They believed that more citizen action was going to be required to save the South Shore, and quickly developed some ideas for a public relations campaign to keep the abandonment issue in the public spotlight. Their strategy focused on demonstrating the potential for increasing the railroad's passenger business by promoting a series of South Shore excursions to the Indiana Dunes and other tourist attractions. Since the railroad ran through the entire 20-mile length of the expanding Indiana Dunes National

Lakeshore, they also believed it was important to demonstrate the railroad's potential to bring people to the park.

The National Park Service was starting to develop transportation and access plans for the park, and preservation of the South Shore was seen as an important element in this planning process. As longtime supporters of the national lakeshore, Lois and Lee believed that one of the goals of this new group should be to show that large numbers of people could still be enticed to ride the South Shore Line to visit the dunes, just as they had during the Insull era. They also believed that the beautiful old posters appearing in Middleton's book could once again be used as important promotional tools to attract attention and riders.

Because of this focus on the recreational rider, they decided to name the group South Shore Recreation. While working for the Environmental Protection Agency (EPA) in Chicago, Lee learned about an agency called the National Center for Appropriate Technology, which provided small amounts of seed money to grass-roots organizations whose focus was on energy conservation. After finding out about their guidelines, she wrote a proposal arguing that the preservation of our nation's last interurban for daily commuters as well as national park visitors was a good example of the use of appropriate technology. The Center liked the idea and approved a small grant of $5,000 as seed money to help get the group started.

The winter of 1977 was one of the worst in recent memory, and by the middle of January I realized that I was not going to be able to survive the howling winds roaring off Lake Michigan in my cute, unwinterized cottage. So I left Beverly Shores in the middle of a blizzard searching for warmer weather, and I ended up in San Francisco visiting some old friends, again wondering what I was going to do with the rest of my life. But I stayed in touch with Lee, who called when the grant award was announced. She told me they had hired a young married couple to run the project during the summer, but asked if I would consider taking over when they returned to graduate school in August. I told her I was definitely interested and started making plans to return to the Region once again.

Although I had talked to Lois Weisburg several times on the phone, I had never met her in person until the day after I returned from San Francisco. I knew about her reputation as a mover and shaker, but didn't really know what to expect when we first met in her office in Chicago. At the time she was working for Business and

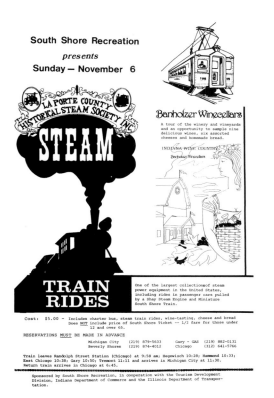

Professional People for the Public Interest, one of several civic organizations she had helped to create. I listened to this chain-smoking dynamo describe her vision for South Shore Recreation. With creative ideas and energy just pouring out of her, I knew right away she was someone who could make things happen—a feeling apparently shared by mayors Harold Washington and Richard Daley, for whom she worked as Director of Special Events and Commissioner of Fine Arts, respectively.

Lois's interest in the South Shore began when her family bought a summer place in Long Beach many years ago. "My family always used the train to get to and from our cottage," she explains. "When we heard about their proposal to end the passenger service, I knew right away that something had to be done. I said to my husband, Bernie, that we can't let this happen. He told me it would have to be my cause because I had the time and he didn't. So I went out and did some research on the South Shore, and concluded that the most effective strategy was not to focus on the commuters, who had already formed their own group, but to try to attract more recreational riders. I believed we could get more publicity and attention by demonstrating that the South Shore is the only train in the country that can bring people from a large city to a nearby national park."

"We had a lot of fun with South Shore Recreation, organizing excursions to the Indiana Dunes and to other attractions," she continues. "Most Chicagoans already knew about the dunes, so that's where we focused our attention in the beginning. But later on we broadened our focus and ran excursions to other places. We began to meet regularly with Al Dudley, the president of the South Shore, to try to persuade and cajole him into helping us in different ways. We knew that Dudley's bosses in Baltimore wanted him to get rid of the passenger service, but that didn't stop us from asking him to help us. Now Mr. Dudley, as we called him, was a real character. He looked and acted like a real railroad tycoon—he could talk pretty tough, especially when he was in the same room with his two loyal assistants, Dick Bunton and Dick Shipley. They all smoked these big, smelly cigars, and tried to look very stern and businesslike. I'm sure they didn't like meeting with us, but we all played the game and were cordial to each other.

"Now Mr. Dudley was a real southern gentlemen. He never raised his voice or talked down to us even when we were asking him to make some basic improvements, like washing the windows and seats in the cars or installing a new train stop at Kemil Road in Beverly Shores for park visitors. We even volunteered to go wash the windows ourselves, but Dudley said that couldn't be done because of liability concerns. I remember one meeting where we asked him to develop a cost estimate for the new stop at Kemil Road. At our next meeting, he told us the new stop would cost $700, but that the railroad wasn't willing to pay for it. I impulsively told him that South Shore Recreation would foot the bill, even though I knew we didn't have the money. Remember—this was before the Northern Indiana Commuter District had been created, so there was no public entity to help fund the passenger service.

"After the stop, which was really just a gravel platform next to the road, was built, Mr. Dudley sent us a bill for $700 every month. Just to get him off our backs, I finally sent him a personal check for it. A couple of days later, he called to tell me that the railroad couldn't accept my check, and then he offered me a deal. He said that if I stopped badmouthing him in the press so much, he would forgive the debt. I agreed to tone down the rhetoric as long as he continued to work with us, although I reserved the right to criticize his policies if I believed they were not in the best interests of the passengers. Overall, I think we had a pretty good relationship with each other. We learned how to do business with each other, even though we may not have always liked each other. He was usually pretty straightforward with his opinions, and so were we. Even though we often had different goals, we were usually able to work together to get things done."

During my initial meeting with Lois, she described the next South Shore Recreation excursion to the Chicago Jazz Festival in Grant Park and asked me if I would spend the next few days in Northwest Indiana promoting this excursion. After meeting with her for an hour, I was pumped up and ready to go. I decided to begin my quixotic quest at Gary's City Hall, where I knew a couple of people who were jazz buffs. I stopped by to see Barbara Wesson, who worked in the city's Urban Conservation office. She seemed to know everyone in the city, and I figured she could help me make contacts with the right people. One of the places she recommended was Mona's Lounge on Broadway, which featured live jazz on weekends. After leaving city hall, I drove down to Mona's and gave the proprietor a bunch of flyers, and she promised to pass them out to her customers. I also contacted the local papers and radio stations in Gary. During the next few days, I visited newspaper offices and radio stations in Michigan City, South Bend, Chesterton, Hammond, and East Chicago. With few exceptions, everyone I contacted was interested in our cause and willing to provide coverage for the event.

When I boarded the two-car train in Miller on the day of the festival, I had no idea how many people would actually show up. I was pleasantly surprised to see about fifty people already sitting on the normally empty train. Most of them looked like they were going to the jazz festival. But the real surprise came when we arrived at the next stop in downtown Gary, where a large crowd was waiting on the platform. I couldn't believe that our little flyers and press releases had worked so well. More than 100 people boarded the train at Gary, and they were definitely in a partying mood. Picnic baskets, with beer, wine, and other goodies, quickly appeared, and were passed from one group to another.

When we arrived at the 12th Street/Roosevelt Road stop in Chicago, the train emptied and everyone followed me up the rickety wooden stairs, over the tracks and above Lake Shore Drive to the old band shell in Grant Park. An usher greeted us when we arrived and directed us up to the first few rows in front of the stage, where Lois had secured an entire section of prime seats for our group. During one of the intermissions there was even an announcement about the special guests who had arrived by train from Indiana. We felt like real VIPs. That first excursion was exhilarating. I was amazed at how many people showed up and how much fun everyone had. I especially liked the fact that white people from Chesterton, blacks from Gary, and Hispanics from East Chicago all rode the same train and actually had a good time interacting with each other.

I wholeheartedly threw myself into the job of organizing and promoting these excursions because I really believed in what we were doing, and I enjoyed doing it. Though the future of the South Shore Line was still very much up in the air, I felt the attention and publicity we were bringing to the effort could make a real difference in saving the service. I began planning a series of fall excursions to different destinations, with an emphasis on trips to the eastern end of the line. These included trips to a Notre Dame football game, the Banholzer Winery in LaPorte County, and to Hudson Lake, which was probably our most unusual trip because we carried several inflatable rubber boats with us on the train. One of the Chicago television stations even sent a crew down to the Randolph Street station to film us getting on the train with our inflatable boats. When we arrived at the Hudson Lake stop two hours later, we blew up the boats and proceeded to paddle around the lake for a couple of hours before catching the train back to Chicago. For the excursion to Bahnholzer Winery and the International Friendship Gardens, I found a school bus driver who was willing to meet us at the train station in Michigan City and drive us to our destinations for a reasonable price. Although the school bus didn't exactly provide a luxury ride, the price was right—$1 per person—and no one complained about the rigid, tiny bus seats.

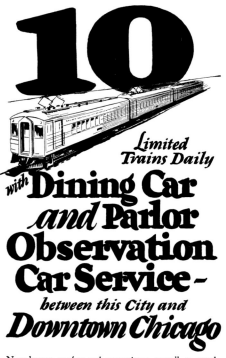

# 10

### Limited Trains Daily

## with Dining Car and Parlor Observation Car Service –

### between this City and Downtown Chicago

Now, luxury, comfort and convenience as well as speed and frequent service for those who have occasion to travel between this city and Chicago.

## No Better Way to Travel

New steel cars, improved roadbed, new automatic block signals, more trains, faster running time, no smoke, no cinders.

Good meals in the dining cars. Service a la carte. Light refreshments served in the parlor-observation cars.

Ride in a parlor-observation car or eat a meal in a dining car the next time you travel on the South Shore Line. You will enjoy it. The parlor cars are divided into cozy homelike compartments—private smoking room for men and private rest room for women. Glass enclosed observation platform.

All South Shore Line trains are electrically operated from South Bend to downtown Chicago—[Terminal station: Randolph Street at Michigan Avenue.]

A train to Chicago every hour on the hour from 5 a.m. to 9 p.m., then 11 p.m.

### Schedule of Dining Car and Parlor-Observation Car Trains

| | Fort Dearborn Limited * | Grant Park Limited X | Illinois Limited | Randolph Limited X | Garden City Limited * |
|---|---|---|---|---|---|
| | AM | *AM | Noon | PM | PM |
| Lv. South Bend .. | 7:00 | 10:00 | 12:00 | 3:00 | 5:00 |
| Lv. New Carlisle | f7:23 | f10:23 | f12:23 | f3:23 | f5:23 |
| Lv. Michigan City† | 7:51 | 10:51 | 12:51 | 3:51 | 5:51 |
| Lv. Tremont .... | f8:06 | f11:06 | f1:06 | f4:06 | f6:06 |
| (Gateway to Indiana Dunes State Park) | | | | | |
| Lv. Gary......... | 8:30 | 11:30 | 1:30 | 4:30 | 6:30 |
| Lv. East Chicago. | 8:45 | 11:45 | 1:45 | 4:45 | 6:45 |
| Lv. Hammond ... | 8:51 | 11:51 | 1:51 | 4:51 | 6:51 |
| Ar. (Randolph St.) | 9:30 | 12:30 | 2:30 | 5:30 | 7:30 |
| **Downtown Chicago** | AM | PM | PM | PM | PM |

| | Notre Dame Limited | Dune-land Limited X | Indiana Limited | Mar-quette Limited X | St. Joe Valley Limited |
|---|---|---|---|---|---|
| | AM | AM | Noon | PM | PM |
| Lv. **Downtown Chicago** (Randolph St.) | 7:00 | 10:00 | 12:00 | 3:00 | 5:00 |
| Lv. Hammond ... | 7:35 | 10:35 | 12:35 | 3:35 | 5:35 |
| Lv. East Chicago. | 7:41 | 10:41 | 12:41 | 3:41 | 5:41 |
| Lv. Gary......... | 8:00 | 11:00 | 1:00 | 4:00 | 6:00 |
| Lv. Tremont ..... | f8:21 | f11:00 | f1:21 | f4:21 | f6:21 |
| (Gateway to Indiana Dunes State Park) | | | | | |
| Lv. Michigan City† | 8:37 | 11:37 | 1:37 | 4:37 | 6:37 |
| Lv. New Carlisle | f9:07 | f12:07 | f2:07 | f5:07 | f7:07 |
| **Ar. South Bend ..** | 9:33 | 12:33 | 2:33 | 5:33 | 7:33 |
| | AM | PM | PM | PM | PM |

A.M. figures in light face type; P.M. figures in bold face type.
f—Stops on signal to receive and discharge passengers.
In Chicago, all trains stop at Van Buren, Roosevelt Road (Central Station, Fifty-third St., Sixty-third St., and Kensington, South Shore Line—Illinois Central Suburban stations. *Dining Car. X–Parlor Car. †Transfer at Michigan City to Shore Line Motor Coaches for Western Michigan Points.

### Chicago South Shore & South Bend Railroad
A. J. Bankson, Ticket Agent
301 North Michigan, Phone Main 0440

---

I loved my new job. In addition to pursuing a worthy cause, I was making my own personal rediscovery of Northwest Indiana. I particularly enjoyed the trips to destinations that were not that well-known. While it was relatively easy to organize trips to popular attractions like the Indiana Dunes and the Chicago Jazz Festival, the real challenge was getting people to ride the train to the east end of the line (where ridership was lightest). While these trips were not as successful in terms of numbers of participants, we were able to show that people would ride the train to these destinations if they knew about them. Many of our new riders came after Lois convinced one of her friends at WFMT-FM, Chicago's popular classical music station, to run some free ads promoting the excursions.

In addition to coming up with innovative trips to keep the South Shore in the spotlight, we also needed to figure out a way to raise some more funds because our $5,000 grant from the Center for Appropriate Technology was almost gone. One idea we discussed was the possibility of reprinting and selling some of the old South Shore posters to publicize our cause and make enough money to keep the organization going. These posters had recently been rediscovered by Dave Gartler, who owned Poster Plus, a store in Chicago specializing in vintage posters. In 1972, someone came into Dave's store with a collection of original 1920s posters promoting the South Shore, North Shore, and Chicago Elevated Lines. This person, an established lawyer in Chicago, had found them in a storage locker. It didn't take Dave long to realize the posters' value, and that reproductions could generate a lot of interest and profits.

Dave worked out an arrangement to restore and exhibit some of them at his store. This was the first public exhibition of the posters, and it received a great deal of attention and publicity. "Shortly after the exhibit closed, I decided to reprint our first vintage poster," he recalls. "I chose the South Shore's *Girl on the Beach* [i.e. *The Dunes Beaches by South Shore Line*, p. 55] because of its appealing image and wonderful design. This poster has been our number one seller through the years and is now in its third printing with over 9,000 of them sold." Dave says that the owner of the original posters also donated some of them to the Chicago Historical Society. They reprinted two of them—*Notre Dame Football* (p. 57) and *Winter in the Dunes* (p. 51). "They've sold very well over the years, especially the Notre Dame poster. But none have been as popular as *Girl on the Beach*."

"I think the reason these posters have been so popular is a combination of good artwork and nostalgia for simpler, happier times. There seems to be a particularly strong interest in transportation posters right now, particularly train posters, all over the world, but especially in England. In recent years there's been an explosion of interest in all kinds of vintage posters in Europe as well as here." Dave continues to reprint and distribute vintage South Shore posters to retailers around the country. "I don't see an end to the popularity and interest in these posters. There's something about them that appeals to people who have never heard of the South Shore Line. People just like them. Each original South Shore poster is now worth thousands of dollars. I don't even want to tell you how much, because it will just drive the price up higher."

When South Shore Recreation first became aware of the posters in 1977, we quickly realized that they could be an important marketing tool in our fledgling citizens' effort to save the railroad. Most of them depicted scenes of recreational attractions along the line that still existed, so the idea of using them once again to promote riding the South Shore to these same destinations seemed quite natural. We believed that using the posters would generate more interest in our effort to save the South Shore. Whenever we met with a potential donor or politician, we'd take along a poster as a gift. We also realized their potential in generating some badly needed cash for our struggling organization. So we came up with a plan to repro-

duce some of the posters ourselves and market them to our mailing list. With their vivid colors and inviting scenes they sold like hotcakes and provided us with a vital source of income.

Later that year, we decided to hold a major press conference to focus attention on the need for local funding to help subsidize the service, culminating our promotional campaign. In addition to the local politicians, we invited the director of the National Park Service, who, surprisingly, accepted our invitation. A large crowd rode the train to the press conference at the park Visitor's Center, across the street from the new Kemil Road train stop (which Lois had tried to pay for with a personal check). The press conference was a rousing success, with one politician after another pledging their support of the South Shore. The Park Service director described the importance of the railroad to the future of the Indiana Dunes National Lakeshore. All of the local media showed up, and two TV stations from Chicago also covered the event.

After the press conference we ran fewer excursions and focused more of our efforts on developing the political support needed to fund the service. I started spending more time with local politicians in the Region as well as in Indianapolis, trying to convince them to create a public entity through which tax dollars would flow to subsidize the service. That winter, the Indiana General Assembly passed legislation creating this new entity—the Northern Indiana Commuter Transportation District. But the matter of funding was still very much up in the air. For several years, the federal government had been offering to pay eighty percent of the cost of a new fleet of rail cars to replace the aging cars originally built by Pullman in 1926. However, the state of Indiana and local governments had to come up with the remaining twenty percent or the deal was off.

In Indianapolis the political contingent from Northwest Indiana still had enough clout to get the Indiana General Assembly to cough up its ten percent, but the real catch was at the local level. While almost every local politician voiced support for the idea of saving the South Shore Line, many balked at the idea of giving money to a rich business like the CSX Corporation, which owned the railroad. These politicians also had a hard time understanding how the South Shore could be losing money if people had to stand while riding rush-hour trains. In response to this concern, we tried to explain the economics of modern-day public transit. The fact that everyone wanted to ride the train during the same peak periods, while few people rode during the rest of the day, meant that the railroad had to employ two shifts of workers to cover both the early morning and evening commutes. Most politicians didn't want to listen to all of these arguments, so we tried to make our case as simple as possible.

Compounding the problem, each of the four counties through which the South Shore ran—Lake, Porter, LaPorte, and St. Joseph—had to come up with its own local share of the dough. Every county had to vote an appropriation of local tax dollars to match the more than $20 million the feds already had on the table for the new equipment. So we went to each of the county commissioners to plead our case and brought along some of our beautiful posters to butter them up. In some cases, I think our little gifts had more of an impact than our impassioned arguments about railroad economics and why they should provide public funds to keep the South Shore operating.

Over the next few months, St Joseph, LaPorte, and Porter Counties agreed to provide their share of the money. All that remained was Lake County. We weren't too sure that our straightforward, sincere citizen approach would be as effective in Lake County, which has had a long history of political corruption and bribery. After some discussion, we decided to go with the same basic strategy of not dwelling on technicalities but making sure that everyone we talked to received a beautiful poster.

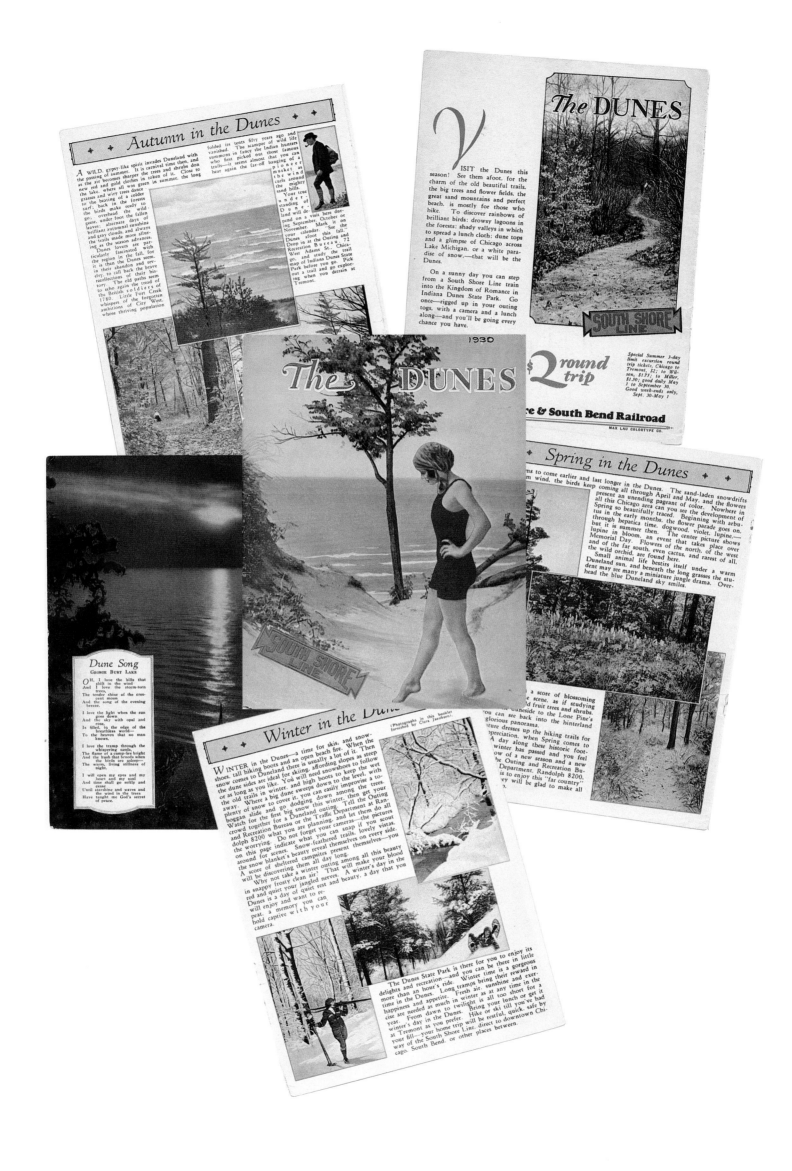

## Autumn in the Dunes

A WILD, gypsy-like spirit invades Duneland with the passing of summer. It is carnival time then, and as the air becomes sharper the trees and shrubs don new red and gold clothes in token of it. Close to the lake, where all was green in summer, the long grasses and wiry trees dance to the beating of a colder surf, and back in the forests go, overhead the wild geese; underfoot the fallen leaves; alternate days of brilliant autumnal sunshine and gray clouds, and always the trails made more alluring as the season advances.

Dunes lovers are particularly fascinated with the region in the fall, for it is then the Dunes seem in their abandon and revelry to call back the brave recollections of their history. The old paths seem to echo again the tread of the British soldiers of 1780, the little Fort Creek whispers of the forgotten ambitions of City West, whose thriving population

folded its tents fifty years ago and vanished. The summer that then, and summons in fancy the Indian life who first picked out those famous trails—it seems almost that you can hear again the far-off banging of a pioneer musket as the wind curls around the mighty sand hills.

Your true understanding of Duneland will depend on a visit here during September, October or November. Mark it on your calendar. See the Dunes afoot this fall. Drop in at the Outing and Recreation Bureau, 72 West Adams St., Chicago, and study the trail map of Indiana Dunes State Park before you go. Pick out a trail and go exploring when you detrain at Tremont.

## The DUNES

**V**ISIT the Dunes this season! See them afoot, for the charm of the old beautiful trails, the big trees and flower fields, the great sand mountains and perfect beach, is mostly for those who hike. To discover rainbows of brilliant birds; drowsy lagoons in the forests; shady valleys in which to spread a lunch cloth; dune tops and a glimpse of Chicago across Lake Michigan, or a white paradise of snow,—that will be the Dunes.

On a sunny day you can step from a South Shore Line train into the Kingdom of Romance in Indiana Dunes State Park. Go once—rigged up in your outing togs, with a camera and a lunch along—and you'll be going every chance you have.

**SOUTH SHORE LINE**

## The DUNES — 1930

**SOUTH SHORE LINE**

**$2 round trip**

Special Summer 3-day limit excursion round trip tickets; Chicago to Tremont, $2; to Wilson, $1.75; to Miller, $1.50; good daily May 1 to September 30. Good week-ends only, Sept. 30–May 1

### & South Bend Railroad

MAX LAU COLORTYPE CO.

## Dune Song

GEORGE BURT LAKE

OH, I love the hills that shift in the wind
And I love the storm-torn trees,
The tender shine of the crescent moon
And the song of the evening breeze.

I love the light when the sun goes down
And the sky with opal and rose,
Is filed, to the edge of the breathless world—
To the heaven that no man knows.

I love the tramp through the whispering sands,
The flame of a camp-fire bright
And the hush that broods when the birds are asleep,
The warm, living stillness of night.

I will open my eyes and my heart and my soul
And time shall go softly and cease
Until starshine and waves and the wind in the trees
Have taught me God's secret of peace.

## Spring in the Dunes

...ms to come earlier and last longer in the Dunes. The sand-laden snowdrifts ...m wind, the birds keep coming all through April and May, and the flowers present an unending pageant of color. Nowhere in all this Chicago area can you see the development of Spring so beautifully traced. Beginning with arbutus in the early months, the flower parade goes on through hepatica time, dogwood, violet, lupine,—but it is summer then. The center picture shows lupine in bloom, an event that takes place over Memorial Day. Flowers of the north, and of the far south, even cactus, and rarest of all, the wild orchid, are found here.

Small animal life bestirs itself under a warm Duneland sun, and beneath the long grasses the student may see many a miniature jungle drama. Overhead the blue Duneland sky smiles.

...a score of blossoming ...d the scene, as if studying ...d fruit trees and shrubs. ...duneside to the Lone Pine's ...glorious panorama. ...you can see back into the hinterland ...ture dresses up the hiking trails for ...appreciation. When Spring comes to ...A day along these historic foot-...ow of a new season and a new ...winter has passed and you feel ...the Outing and Recreation Bu-...Department, Randolph 8200, ...ey to enjoy this "far country" ...ey will be glad to make all

## Winter in the Dunes

(Photographs in this booklet furnished by Clara Jacobsen)

WINTER in the Dunes—a time for skis, and snowshoes, tall hiking boots and an open beach fire. When the snow comes to Duneland there is usually a lot of it. Then the dune sides are ideal for skiing, affording slopes as steep or as long as you like. You will need snowshoes to follow the old trails in winter, and high boots to keep the wet away. When a big dune sweeps down to the level, with plenty of snow to cover it, you can easily improvise a toboggan slide and go dodging down among the trees. Watch for the first big snow this winter, then get your crowd together for a Duneland outing. Tell the Outing and Recreation Bureau or the Traffic Department at Randolph 8200 what you are planning, and let them do all the worrying. Do not forget your cameras—the pictures on this page indicate what you can snap if you scout around for scenes. Snow-feathered trails, lovely vistas, the snow blanket's beauty reveal themselves on every side. A score of sheltered campsites present themselves—you will be discovering them all day long.

Why not take a winter outing among all this beauty in snappy frosty air? That will make your blood red and quiet your jangled nerves. A winter's day in the Dunes is a day of quiet rest and beauty, a day that you will enjoy and want to repeat, a memory you can hold captive with your camera.

The Dunes State Park is there for you to enjoy its delights and recreation—and you can be there in little more than an hour's ride. Winter time is a gorgeous time in the Dunes. Long tramps bring their reward in happiness and appetite. Fresh air, sunshine and exercise are needed as much in winter as at any time in the year. From dawn to twilight is all too short for a winter's day in the Dunes. Bring your lunch or get it at Tremont as you prefer. Hike or ski till you've had your fill—your home trip will be restful, quick, safe by way of the South Shore Line, direct to downtown Chicago, South Bend, or other places between.

At a raucous meeting a few weeks later, the Lake County Commissioners finally voted, by a scant five to four margin, to provide the necessary funds for the new cars. That was the last piece of the political puzzle, at least for the time being.

With our main mission accomplished, our citizen effort started to run out of steam. We managed to prop up South Shore Recreation for another year, continuing to run occasional excursions to keep the railroad in the media spotlight and maintain our political momentum. The organization finally disbanded the next year, however, when our funds ran dry.

A couple of years later, I accepted a job as marketing coordinator for the Northern Indiana Commuter Transportation District, the public agency created to help fund the South Shore Line. In this position, I continued with many of the activities that South Shore Recreation had initiated, including organizing train excursions. I also pushed hard to "institutionalize" the old posters by convincing my boss that we should reprint and sell some of them in order to generate more marketing activities to increase ridership. The first poster we reprinted was *Homeward Bound* (p. 69), the next was *Winter in the Dunes* (p. 51). Both were very popular and sold out of their first printings.

What is it about these posters that generates so much interest? I think it's a combination of nostalgia and the quality of the artwork. With their pastel colors and vivid images, the posters jump out at you and grab your attention. In this age, supersaturated with glitzy, mass media images, these posters are nostalgic reminders of what advertising looked like before television. They also remind me of what I like about Northwest Indiana—especially the dunes. Since the beginning of this century, artists have been attracted to the Indiana dunes because of their natural beauty and ever-changing colors. The artists who created these posters captured this radiance and tranquillity. Through their images of the flapper girl on the beach and the young, elegantly dressed women cross-country skiing, they also captured some of the flamboyant, fun feeling of the Roaring Twenties.

While teaching history at a large high school in Southern California, I displayed two of these full-sized posters in my classroom. They served as daily reminders of my connection to the dunes and the South Shore, and I also used them as a learning tool for my students. When we studied the 1920s in my history classes, I would talk about the posters and what they symbolized. Many of the students, as well as my teaching colleagues, were fascinated by the posters and peppered me with questions about them and about the South Shore. I often used these questions as opportunities to discuss the important role that interurban railroads once played in this country's transportation networks, including the famous Big Red cars of the Pacific Electric system, which crisscrossed Southern California and came within a few blocks of the school.

Since its near abandonment in the late 1970s, public awareness of the South Shore Line's unique historical status as the country's last electric interurban has grown, while it continues to fulfill its role as a modern commuter train providing access to thousands of jobs in Chicago. Today, the South Shore's future seems secure, despite the lack of a dependable local funding source and continuing threats of cuts in transit funding from the federal government.

Tragically for this country, there aren't many success stories that match the saving of the South Shore Line. For every commuter train that has survived, hundreds of public transit systems have been dismantled, paving the way for the automobiles that now run our lives. Since World War II, our national transportation policy has focused almost exclusively on spending billions of dollars to create a national interstate highway system that has helped to destroy the fabric of our cities, facilitating a mass exodus to the suburbs. We can pretend that everything is all right while driving around in our comfortable, well-insulated sedans, but there's no

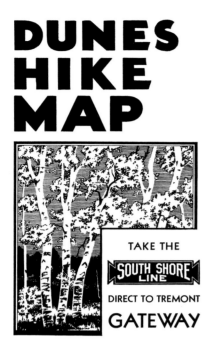

# DUNES HIKE MAP

TAKE THE

**SOUTH SHORE LINE**

DIRECT TO TREMONT

# GATEWAY

escaping the fact that we've created an imbalanced, inefficient transportation system that is literally choking us to death.

I sometimes try to imagine what our society would be like if we had managed to retain the extensive electric public transit systems that once existed. What would our society look like today if our political leaders had had the foresight to preserve at least a portion of these great systems? The cost of saving and improving all of the electric rail systems would have been a miniscule fraction of the twenty billion dollars that the federal government has spent on the construction of the interstate highway system over three decades. But the political mind set from the 1930s through the 1950s was that the old streetcar and interurban systems were outmoded and needed to be dismantled, making way for wider streets and expressways to handle the ever-growing number of automobiles clogging the cities and countryside.

This thinking was strongly encouraged by General Motors, which formed a front company to buy up America's streetcar systems and replace them with GM buses, as Jane Holtz Kay explains in *Asphalt Nation*:

> Attacking the trolley mile by mile, the syndicate of General Motors, Firestone, Standard Oil, and Mack Truck, allied as National City Lines, cajoled and bought off local officials. . . . Between 1932 and 1949, they would help persuade 100 electric systems in more than forty-five cities to scrap their street rail systems. . . . By 1956, the year of the interstate highway act, the National City Line's cabal of oil and automobile interests had finally bought out the last of the electric rail lines. . . . Aided by General Motors' body blows, transit was surrendering.

But the South Shore somehow survived this onslaught, largely because of its route through heavily industrialized Northwest Indiana. Unlike most of the other interurbans across the country, the South Shore always managed to maintain a healthy freight business, which kept the railroad financially solvent through the 1950s and 1960s, even as its passenger business dwindled.

Since its near demise in the late 1970s, the South Shore Line has been transformed into a modern, efficient commuter rail line, carrying an average of 12,000 passengers each weekday. Unlike the other Insull interurbans once based in Chicago, the South Shore was able to survive until the federal government finally began to provide funds for public transportation during the administration of Lyndon Johnson. Tragically, for most of our country's other electric transit systems it was too late. They had already perished.

The fact that the South Shore is still running is remarkable. The last interurban was saved by an unlikely coalition of citizen activists, environmentalists, Chicago civic leaders, Region politicians, and local bureaucrats, bolstered by federal dollars. "The Little Train That Could" continues to serve as an important national symbol of the great electric rail systems that once crisscrossed the national landscape.

# THE POSTERS

*Autumn in the Dunes via South Shore Line*

Oscar Rabe Hanson

1925 (lithograph)
Calumet Regional Archives
Indiana University Northwest
Patron: Mitchell A. Markovitz

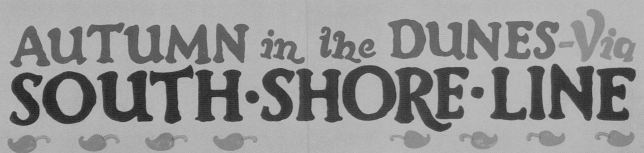

# AUTUMN in the DUNES–Via
# SOUTH·SHORE·LINE

Trains Operated from Chicago over Illinois Central Railroad from
Randolph, Van Buren, 12th, 43rd, 53rd, 63rd, and Kensington Stations.

***Steel Mills at Gary by South Shore Line***

Norman Erickson

1925 (lithograph)
Calumet Regional Archives
Indiana University Northwest
Patron: U.S. Steel—Gary Works

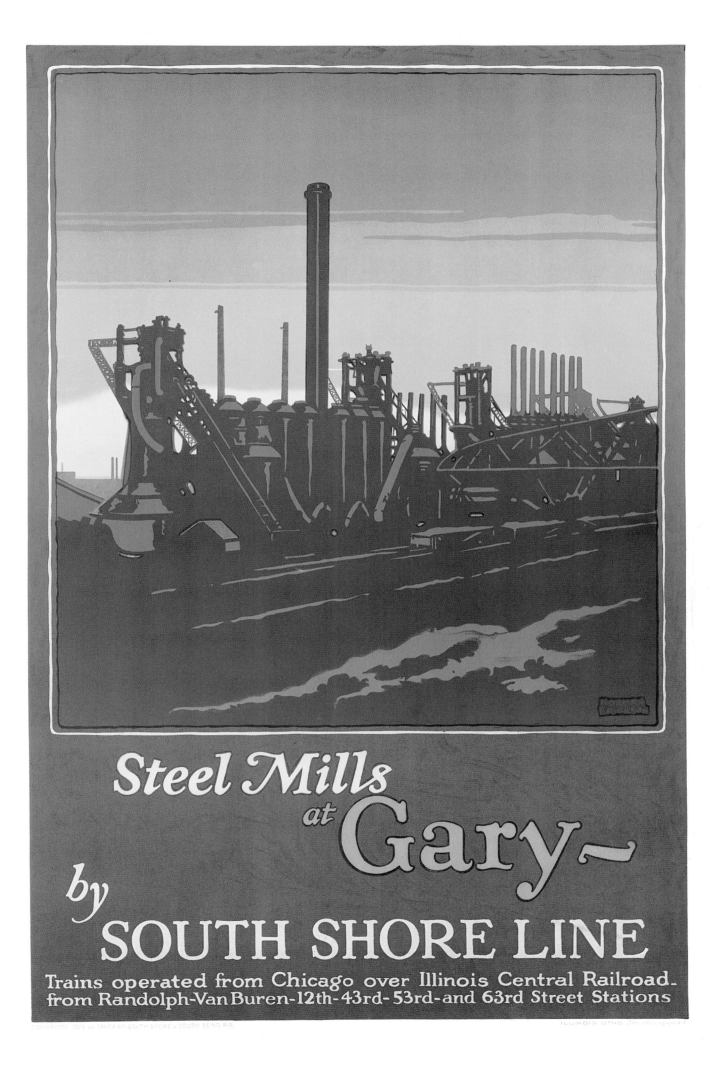

Steel Mills
*at* Gary~
*by*
SOUTH SHORE LINE
Trains operated from Chicago over Illinois Central Railroad.
from Randolph-Van Buren-12th-43rd-53rd-and 63rd Street Stations

*25 Miles of Beach via South Shore Line*

Oscar Rabe Hanson

1925 (lithograph)
Calumet Regional Archives
Indiana University Northwest
Patron: Whiteco

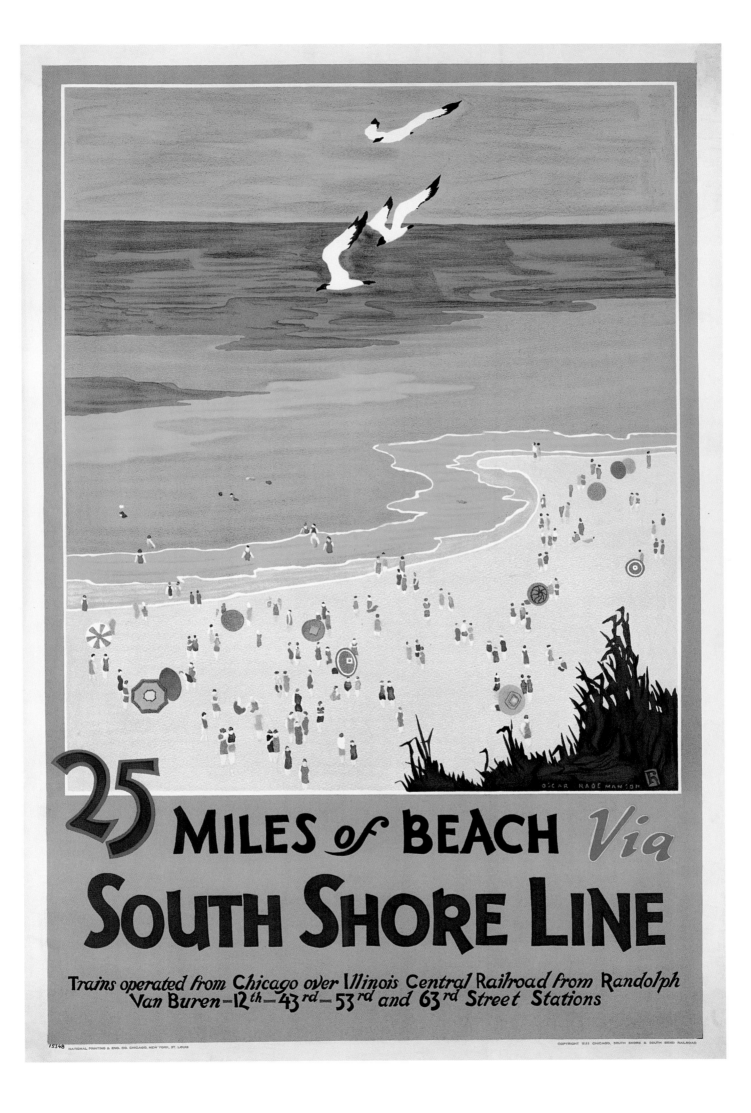

*Winter in the Dunes: South Shore Line*

OSCAR RABE HANSON

1925 (lithograph)
Calumet Regional Archives
Indiana University Northwest
Patron: Partners in Contracting Corporation

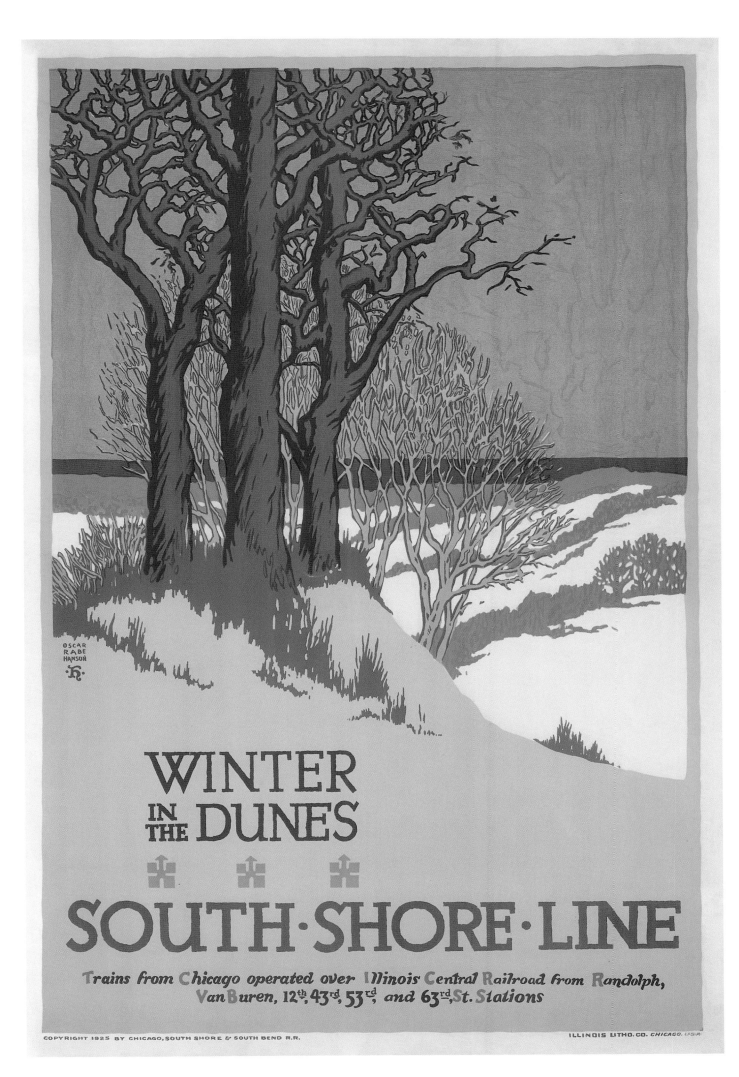

*Winter Sports in the Dunes by South Shore Line*

Oscar Rabe Hanson

1925 (lithograph)
Calumet Regional Archives
Indiana University Northwest
Patron: Northwest Indiana Regional Development Company

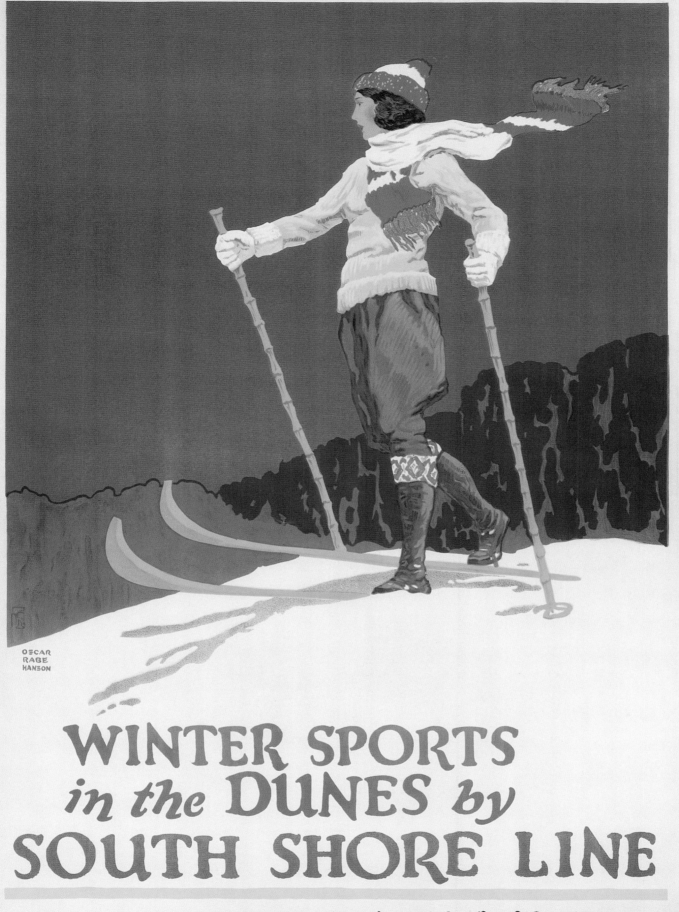

# WINTER SPORTS
## in the DUNES by
# SOUTH SHORE LINE

Trains from Chicago operated over Illinois Central Railroad from Randolph,
Van Buren, 12$^{th}$, 43$^{rd}$ 53$^{rd}$, and 63$^{rd}$ St. Stations

***The Dunes Beaches by the South Shore Line***

Urgelles

1925 (lithograph)
Calumet Regional Archives
Indiana University Northwest
Patron: Family Express Corporation

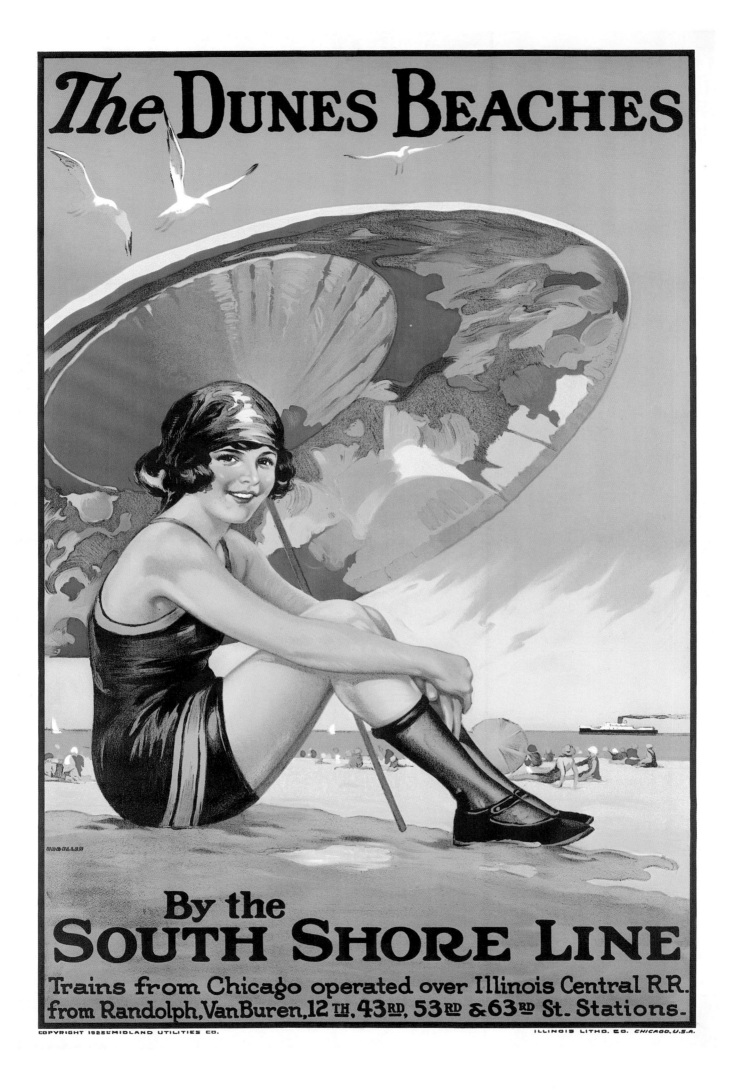

*Football: Notre Dame (South Bend) by South Shore Line*

OSCAR RABE HANSON

1925 (lithograph)
Calumet Regional Archives
Indiana University Northwest
Patron: National City Corporation

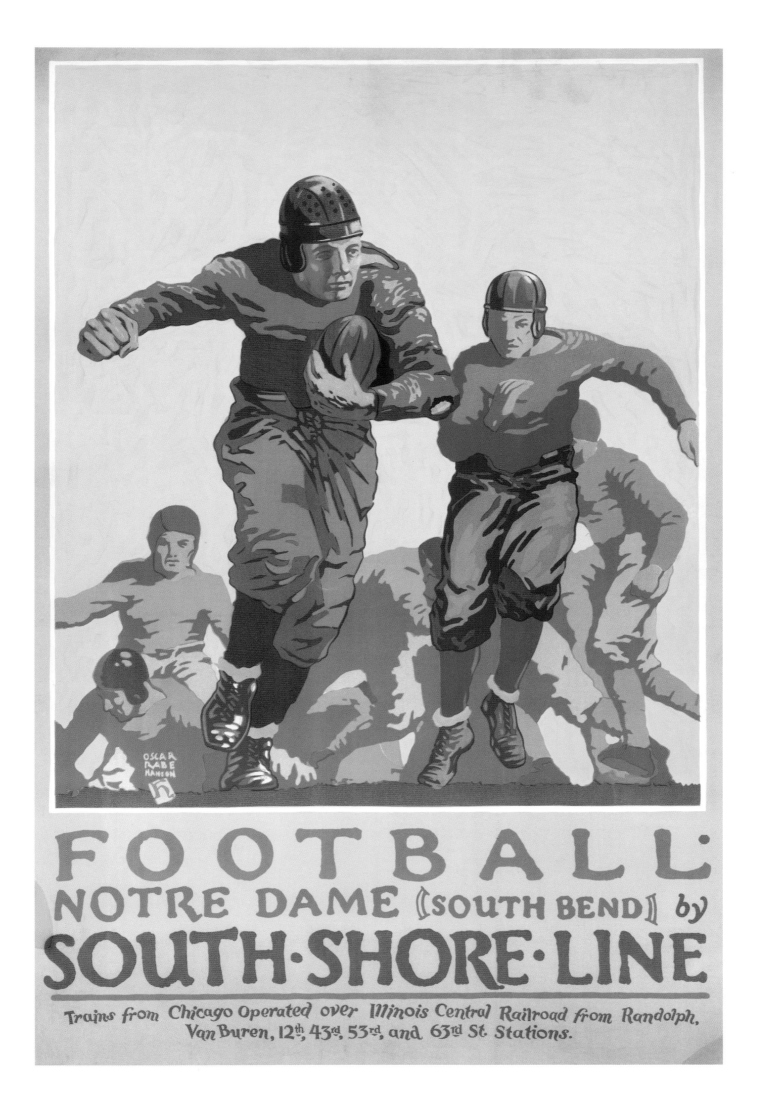

*Visit Duneland . . . via South Shore Line*

ARTHUR JOHNSON

1925 (lithograph; ICHi-27095)
Chicago Historical Society

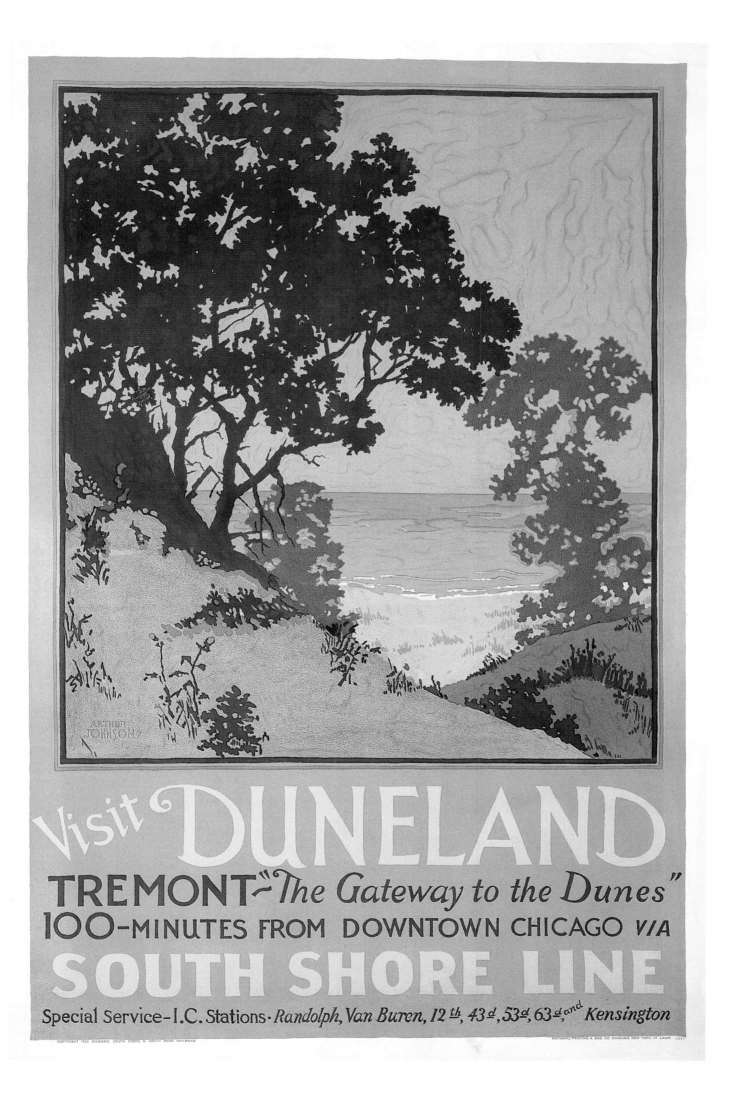

*Dunes Woodland by South Shore Line*

Oscar Rabe Hanson

1926 (lithograph)
Calumet Regional Archives
Indiana University Northwest
Patron: AMOCO—Whiting Refinery

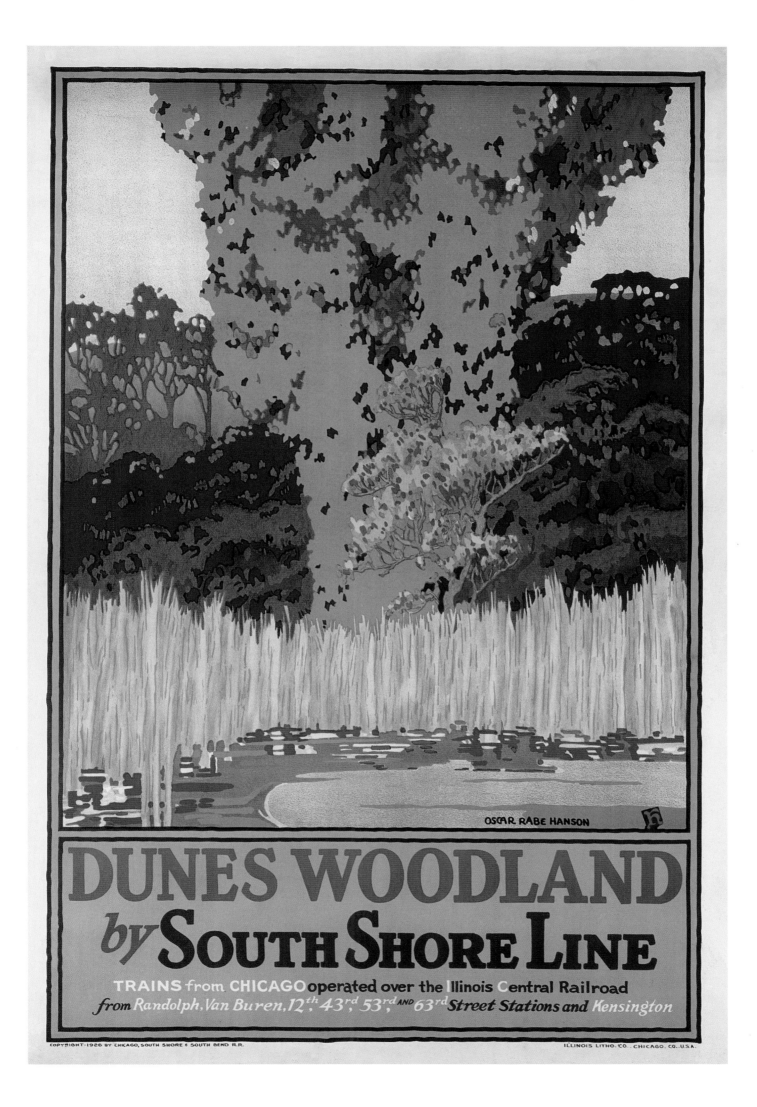

OSCAR RABE HANSON

# DUNES WOODLAND
## *by* SOUTH SHORE LINE

**TRAINS** from **CHICAGO** operated over the Illinois Central Railroad
*from Randolph, Van Buren, 12th, 43rd, 53rd AND 63rd Street Stations and Kensington*

***Visit the Dunes Beaches by South Shore Line***

OTTO BRENNEMANN

1926 (lithograph)
Calumet Regional Archives
Indiana University Northwest

*Visit the Dunes Beaches by South Shore Line*

Otto Brennemann

1926 (lithograph)
Calumet Regional Archives
Indiana University Northwest

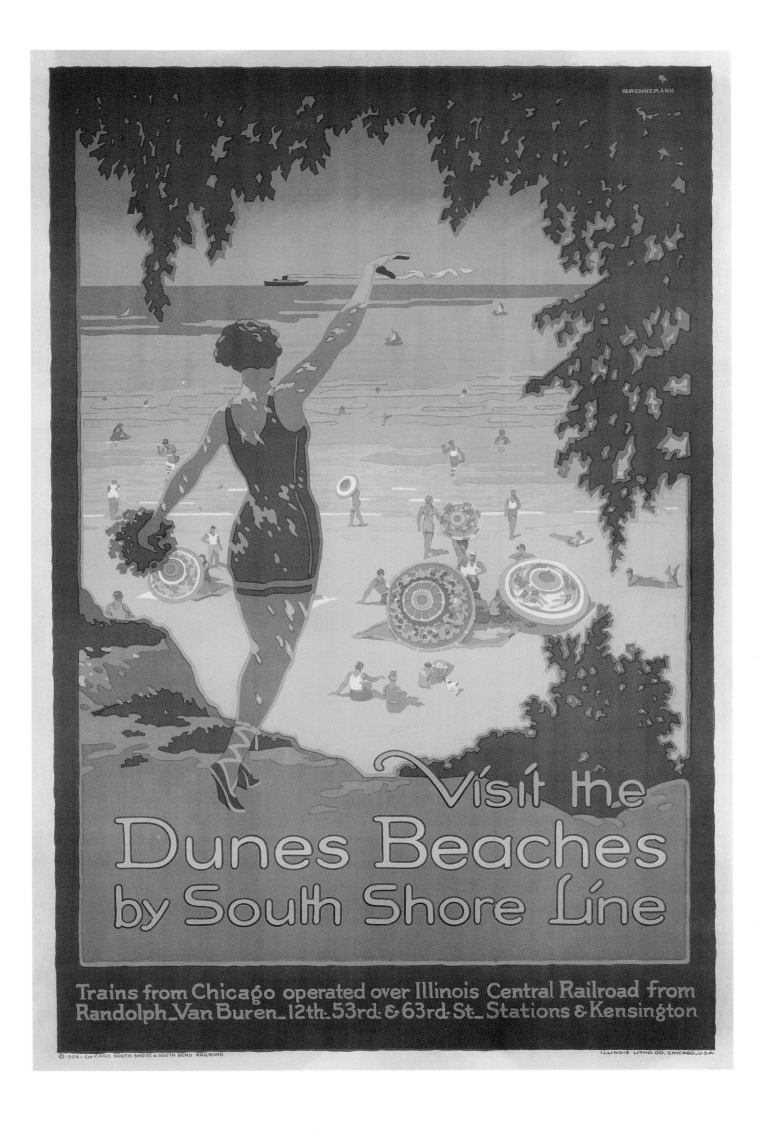

*Visit "The Workshop of America" by South Shore Line*

OTTO BRENNEMANN

1926 (lithograph)
Calumet Regional Archives
Indiana University Northwest
Patron: Crowe Chizek and Company LLP

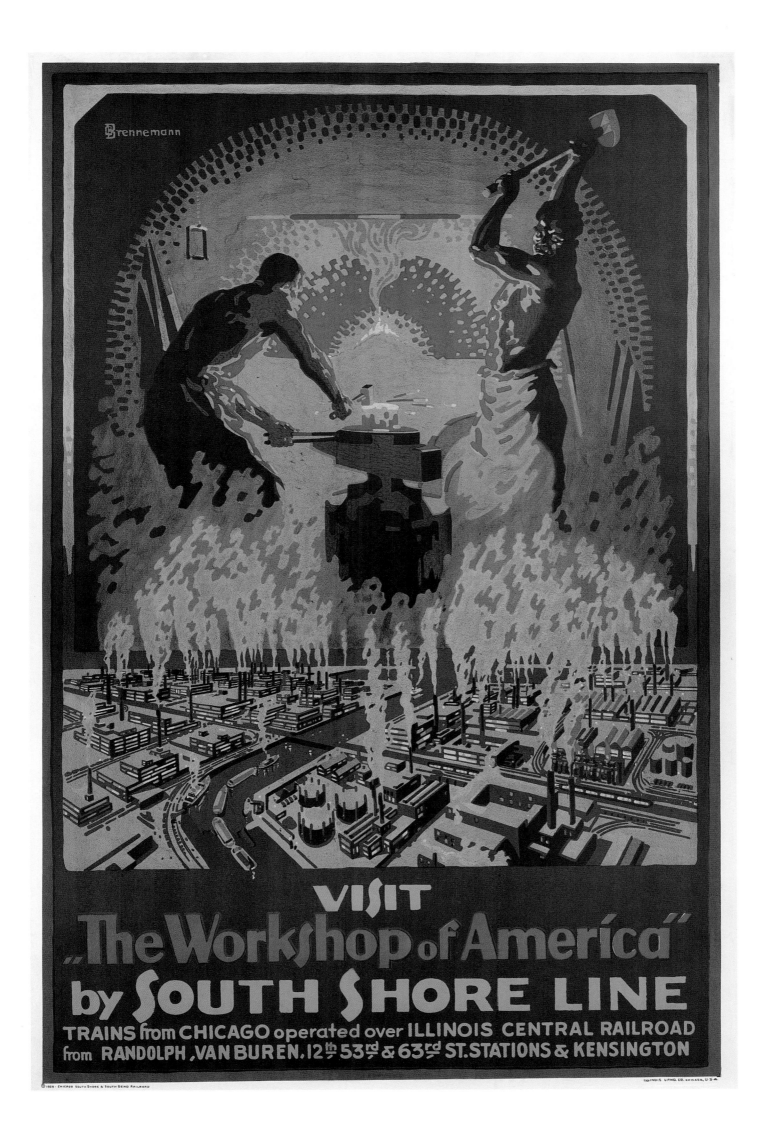

***Homeward Bound by South Shore Line***

OSCAR RABE HANSON

1926 (lithograph)
Calumet Regional Archives
Indiana University Northwest
Patron: Calumet Construction

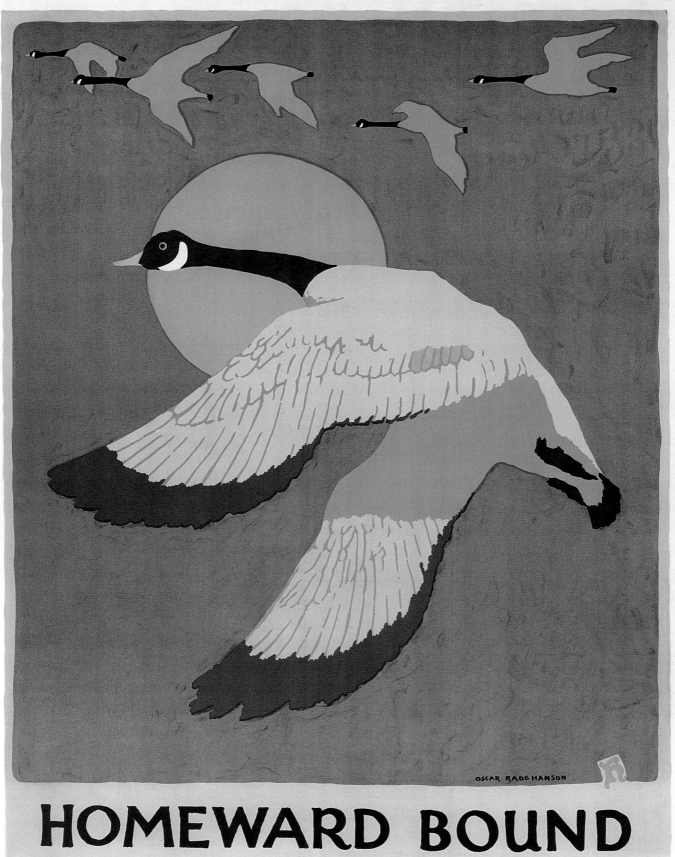

OSCAR RABE HANSON

# HOMEWARD BOUND
# by SOUTH SHORE LINE

TRAINS FROM CHICAGO OPERATED OVER THE ILLINOIS CENTRAL RAILROAD
from RANDOLPH, VAN BUREN, 12th, 43rd, 53rd AND 63rd STREET STATIONS AND KENSINGTON

ILLINOIS LITHO. CO. CHICAGO, U.S.A.

***Autumn: Indiana Dunes State Park by South Shore Line***

OTTO BRENNEMANN

1926 (lithograph)
Calumet Regional Archives
Indiana University Northwest
Patron: WFMT Radio

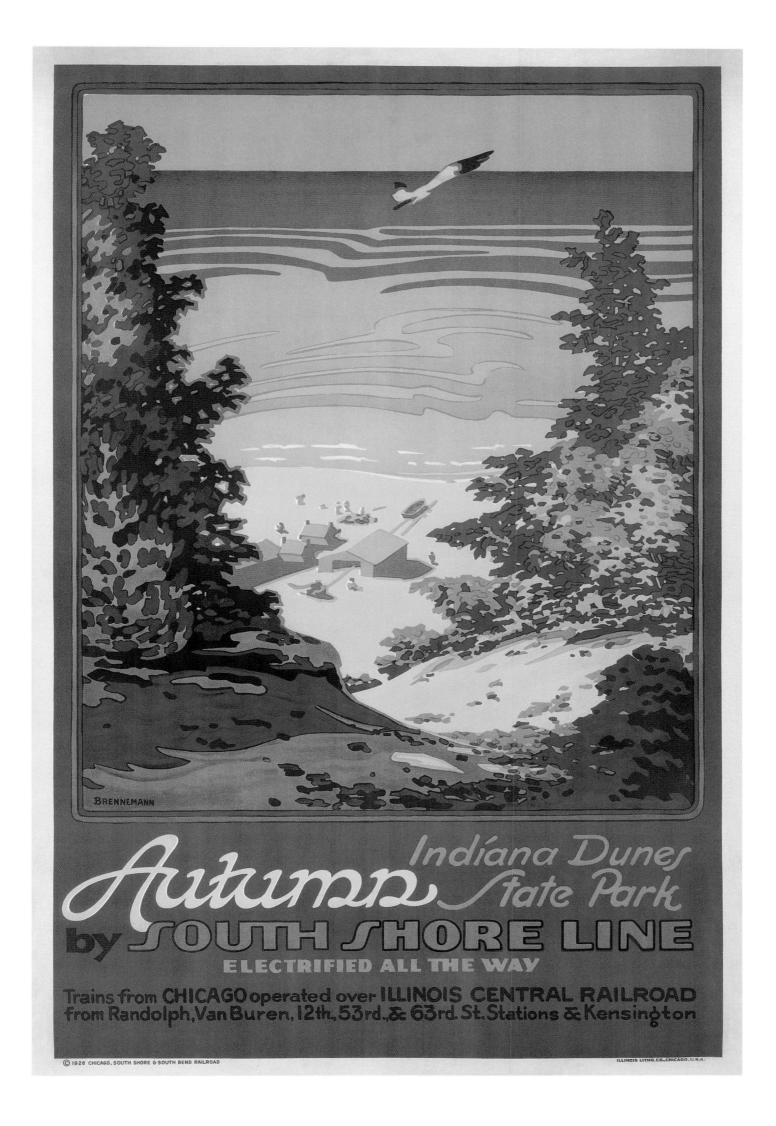

*A Merry Christmas: South Shore Line*

OTTO BRENNEMANN

1926 (lithograph)
Calumet Regional Archives
Indiana University Northwest

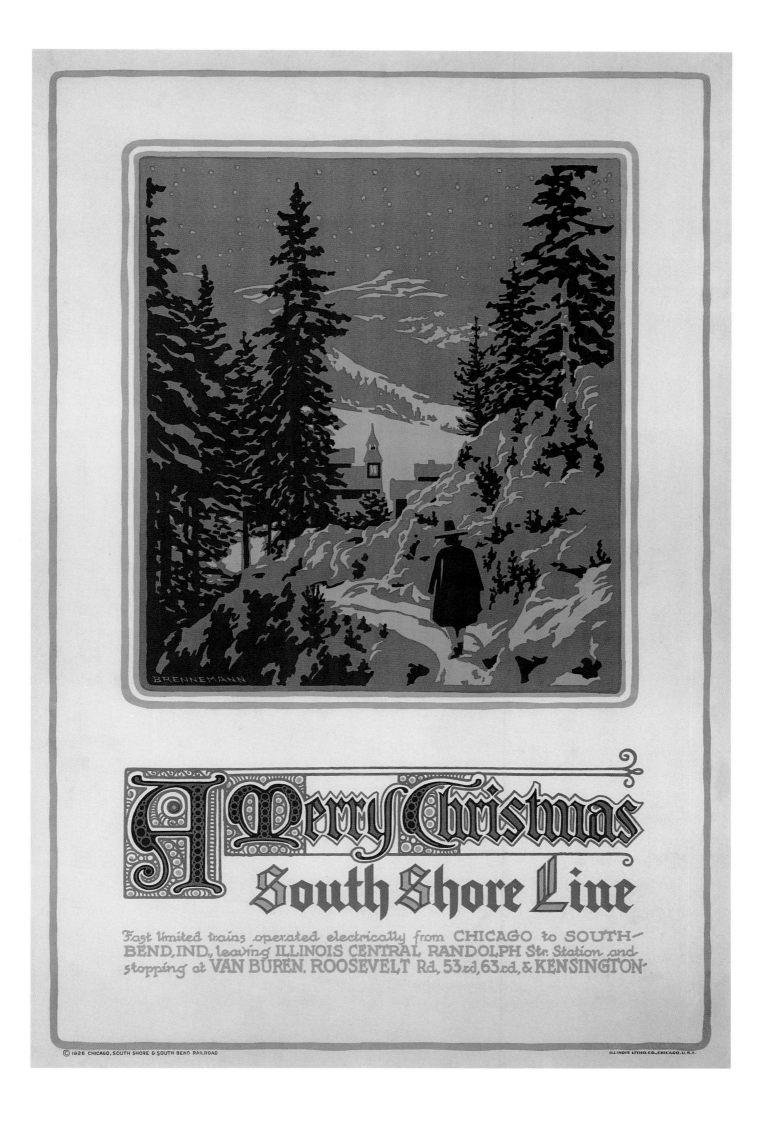

*Football: Notre Dame (South Bend) by South Shore Line*

Otto Brennemann

1926 (lithograph; ICHi-06706)
Chicago Historical Society

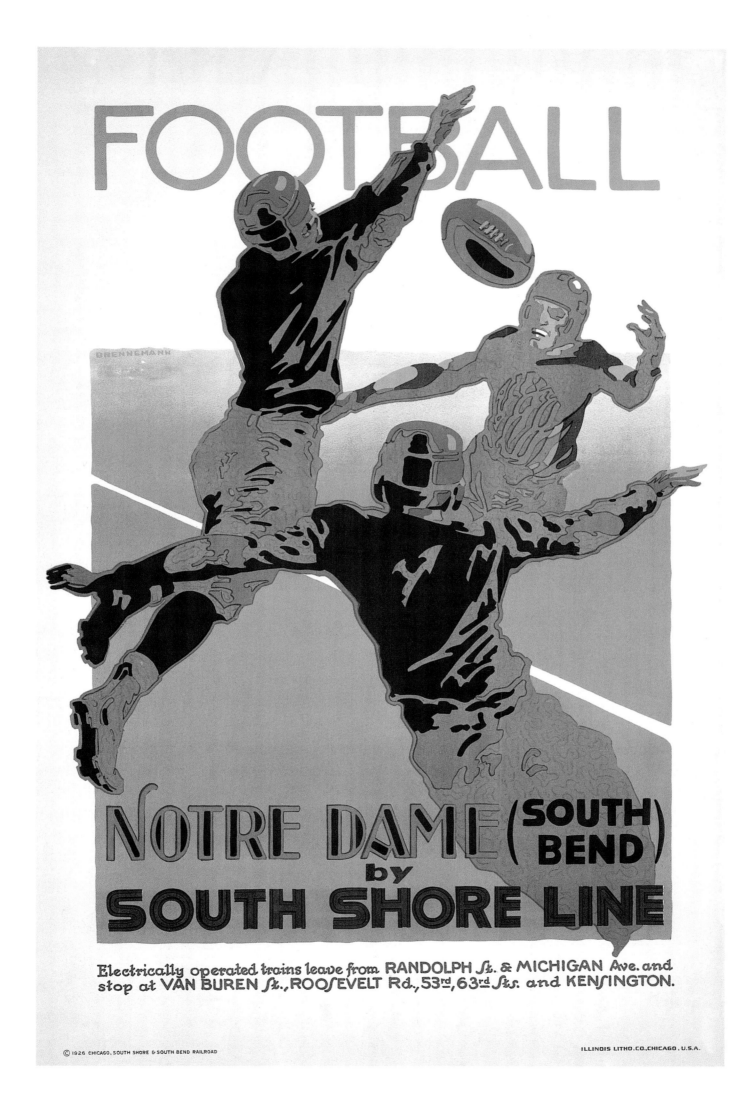

*Hudson Lake by South Shore Line*

LESLIE RAGAN

1927 (lithograph)
Calumet Regional Archives
Indiana University Northwest
Patron: WFMT Radio

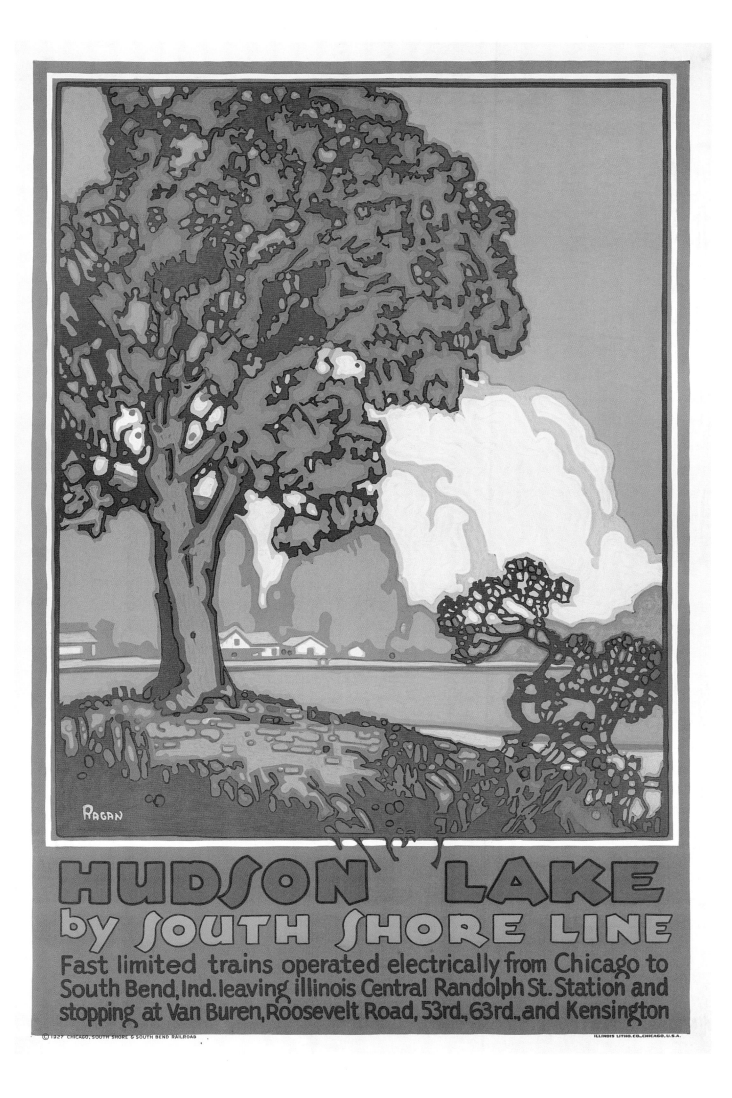

RAGAN

HUDSON LAKE
by SOUTH SHORE LINE
Fast limited trains operated electrically from Chicago to
South Bend, Ind. leaving illinois Central Randolph St. Station and
stopping at Van Buren, Roosevelt Road, 53rd., 63rd., and Kensington

*Springtime by South Shore Line*

Oscar Rabe Hanson

1927 (lithograph)
Calumet Regional Archives
Indiana University Northwest
Patron: Bob Harris

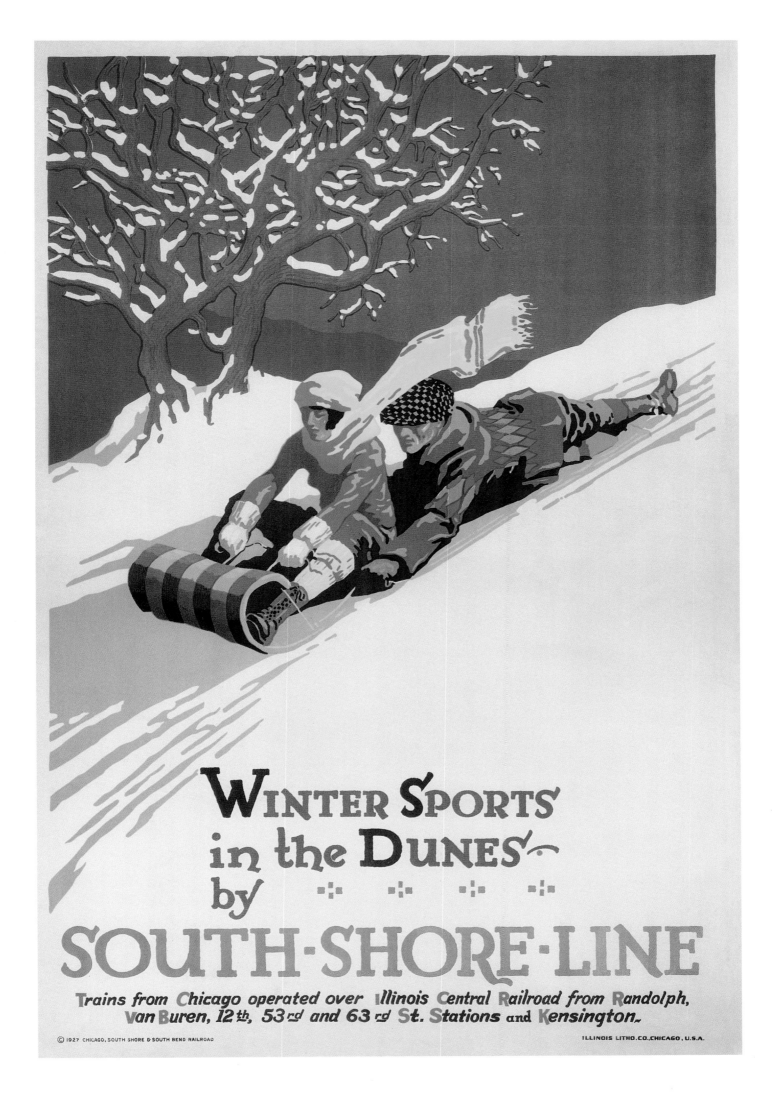

***Indiana Dunes State Park: Only 81 Minutes from Downtown
Chicago by South Shore Line***

Leslie Ragan

1927 (lithograph)
Calumet Regional Archives
Indiana University Northwest
Patron: Hartman and Hartman, P.C., Intellectual Property Attorneys

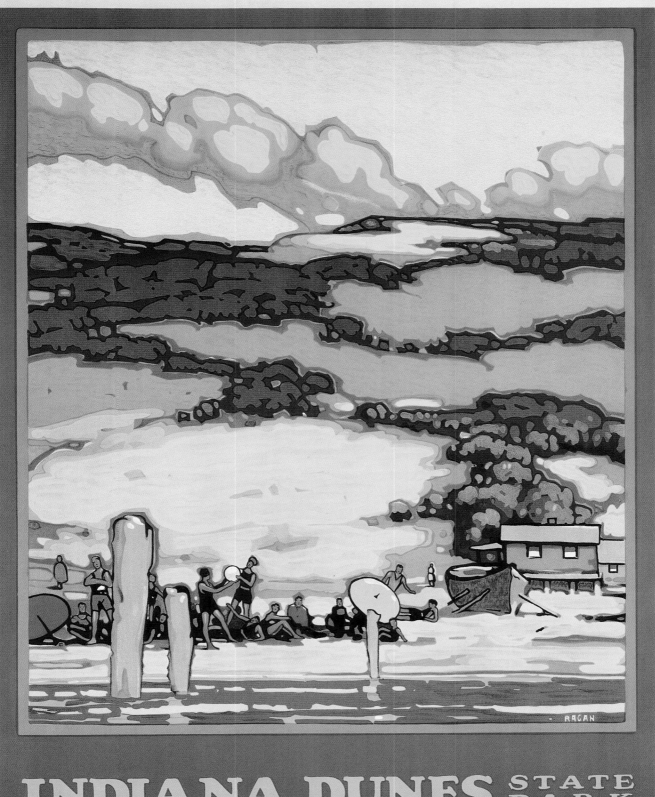

# INDIANA DUNES STATE PARK

## Only 81 Minutes from Downtown Chicago
## by SOUTH SHORE LINE

Fast limited trains operated electrically from Chicago to South
Bend, Ind., leaving Illinois Central Randolph St. Station and stopping
at Van Buren, Roosevelt Road, 53rd., 63rd., and Kensington

Dining Car Service                                    Parlor Car Service

*Moonlight in Duneland by South Shore Line*

LESLIE RAGAN

1927 (lithograph)
Calumet Regional Archives
Indiana University Northwest
Patron: Horizon Bank

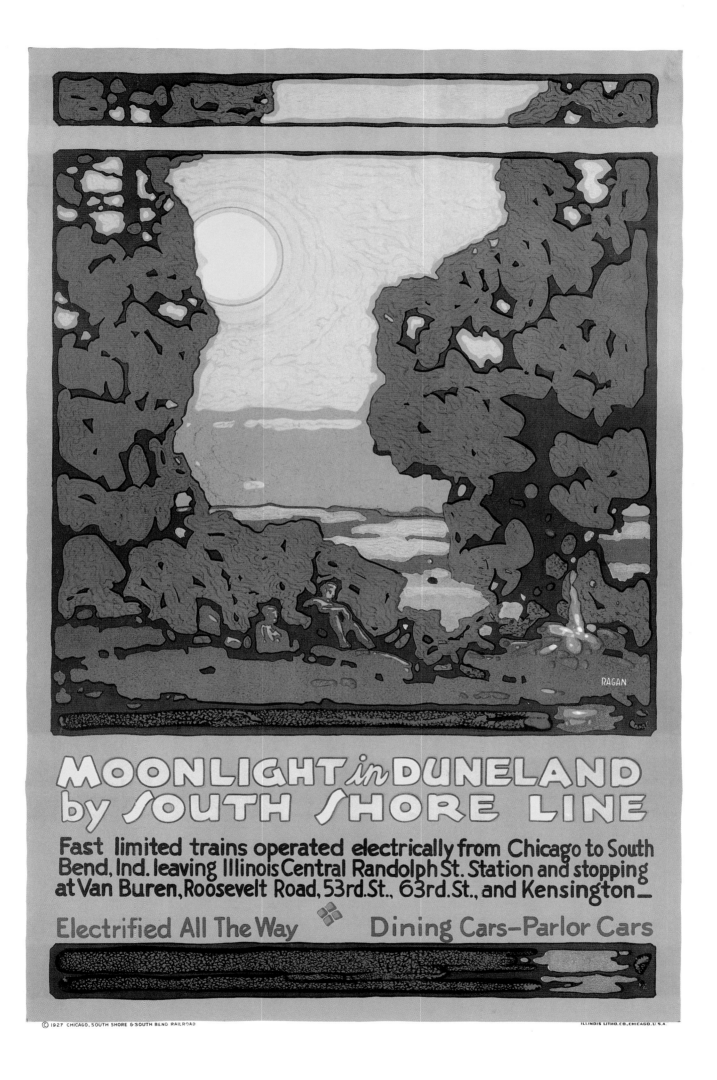

# MOONLIGHT *in* DUNELAND
## by SOUTH SHORE LINE

Fast limited trains operated electrically from Chicago to South Bend, Ind. leaving Illinois Central Randolph St. Station and stopping at Van Buren, Roosevelt Road, 53rd. St., 63rd. St., and Kensington—

Electrified All The Way ✦ Dining Cars–Parlor Cars

ILLINOIS LITHO. CO., CHICAGO, U.S.A.

*Winter Sports by South Shore Line*

Ivan V. Beard

1927 (lithograph)
Calumet Regional Archives
Indiana University Northwest
Patron: Northwestern Indiana Regional Planning Commission

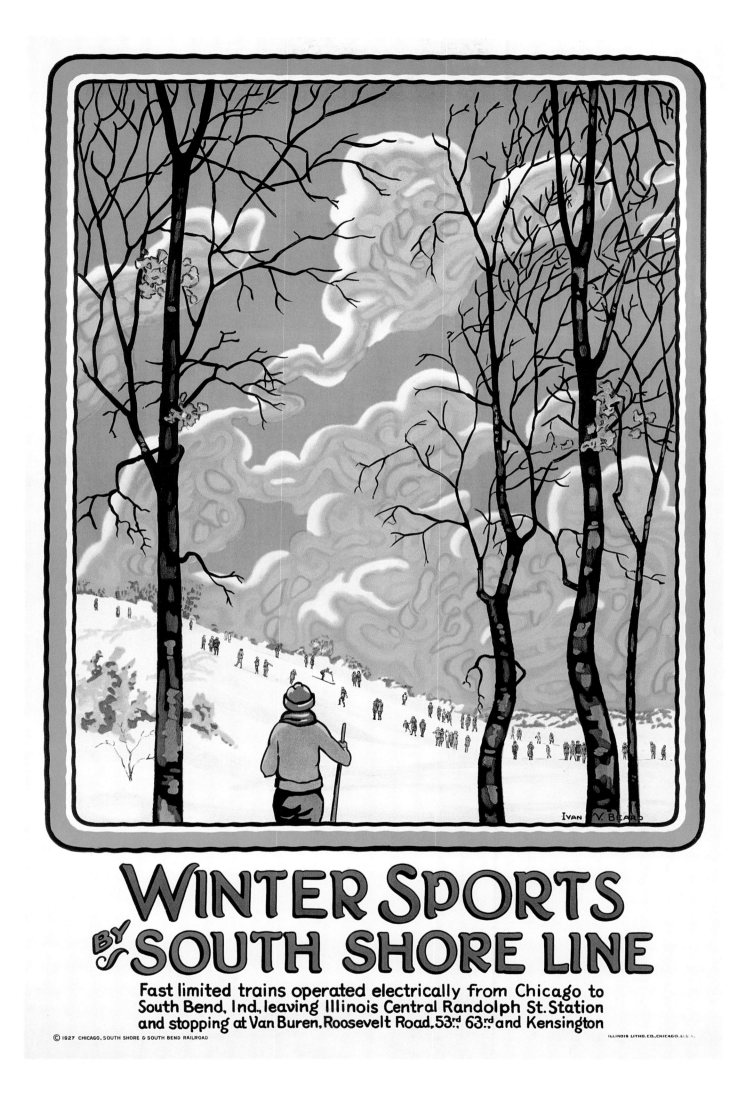

***The Dunes by South Shore Line: Visit Nature's Wonderland***

LESLIE RAGAN

1927 (lithograph; ICHi-27009)
Chicago Historical Society
Patron: WBBM-AM Radio

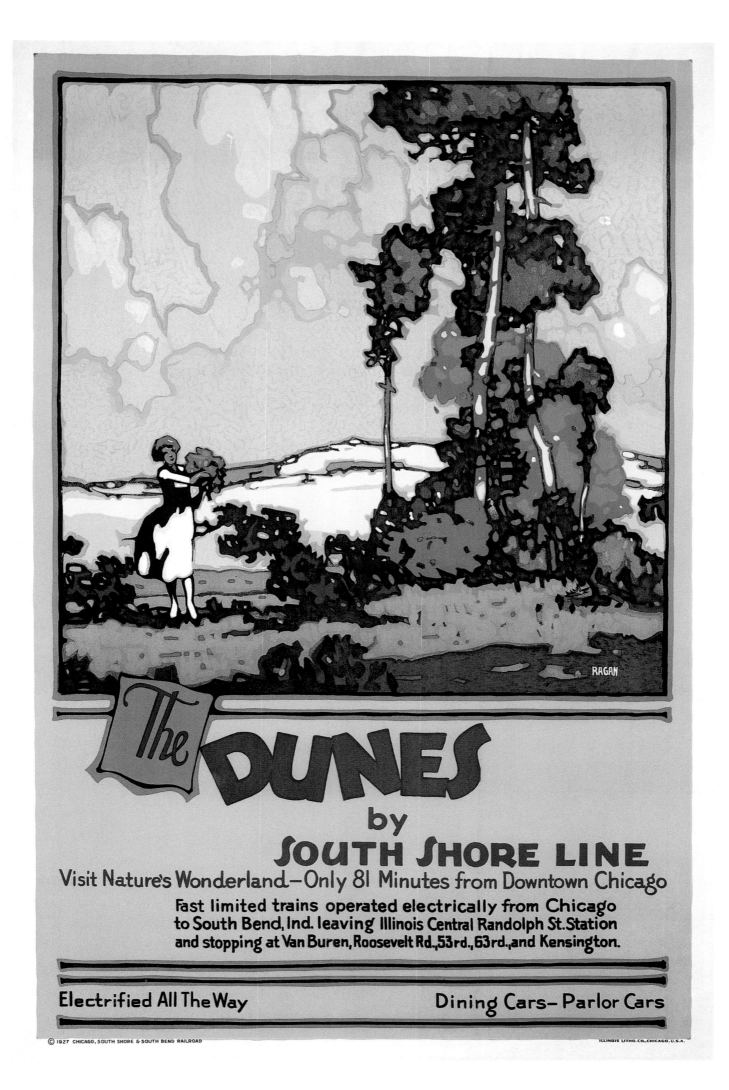

*Spring: Indiana Dunes State Park by South Shore Line*

Clara B. Fahrenbach

1927 (lithograph; ICHi-27092)
Chicago Historical Society

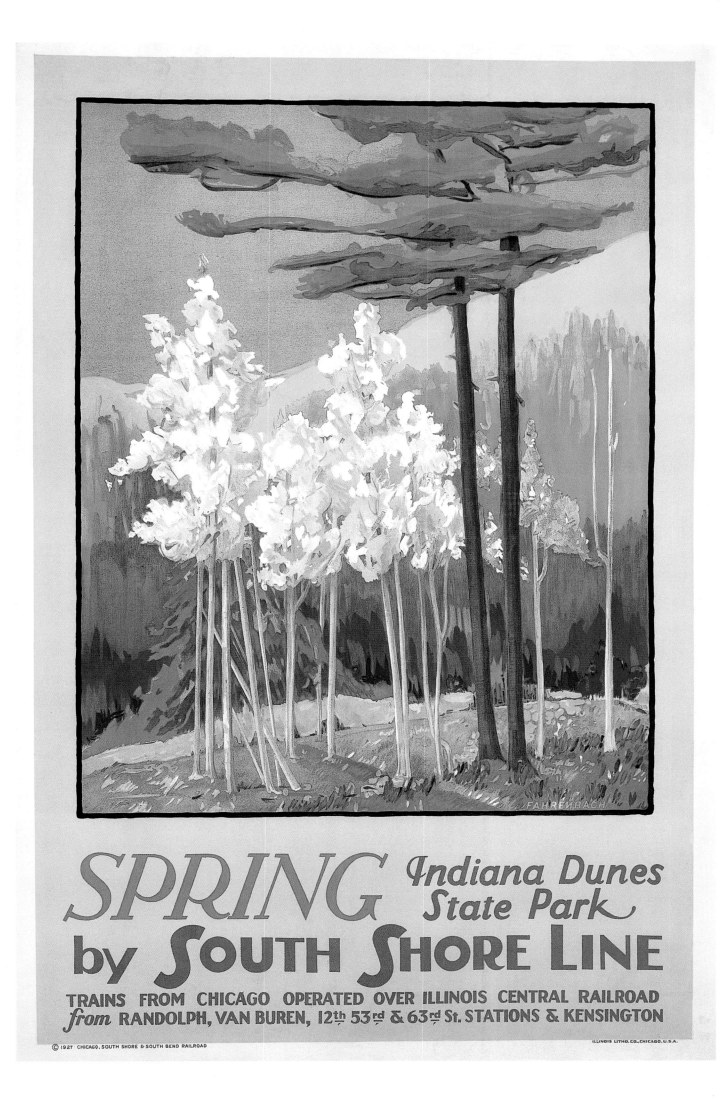

SPRING *Indiana Dunes State Park*
by SOUTH SHORE LINE

TRAINS FROM CHICAGO OPERATED OVER ILLINOIS CENTRAL RAILROAD
*from* RANDOLPH, VAN BUREN, 12th 53rd & 63rd St. STATIONS & KENSINGTON

*Winter in the Dunes by South Shore Line*

RAYMOND HUELSTER

1927 (lithograph; ICHi-27099)
Chicago Historical Society
Patron: WFMT Radio

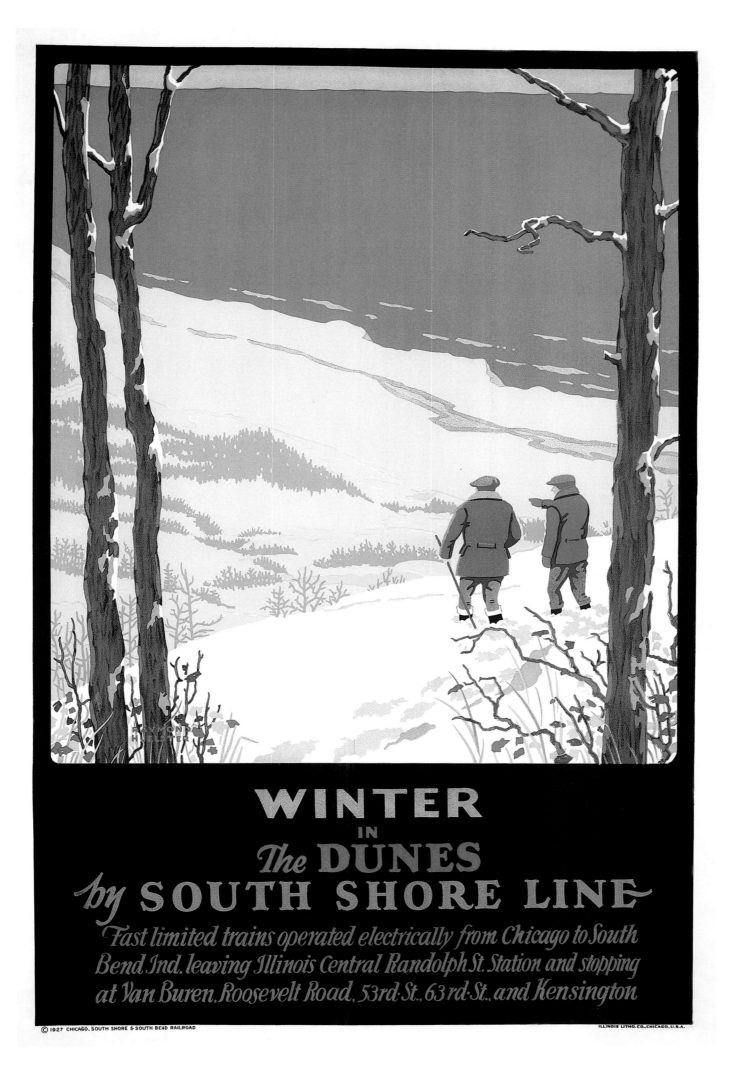

WINTER
IN
The DUNES
by SOUTH SHORE LINE
*Fast limited trains operated electrically from Chicago to South
Bend Ind. leaving Illinois Central Randolph St. Station and stopping
at Van Buren, Roosevelt Road, 53rd St., 63rd St., and Kensington*

*Season's Greetings: South Shore Line*

Leslie Ragan

1927 (lithograph; ICHi-27097)
Chicago Historical Society
Patron: WFMT Radio

Season's Greetings
SOUTH SHORE LINE

Fast Limited trains operated electrically from Chicago to South Bend, Ind. leaving Illinois Central Randolph St. Station *and* stopping at Van Buren, Roosevelt Rd., 53rd., 63rd., and Kensington.

*Blossomtime in Michigan by Shore Line Motor Coaches*

OTTO BRENNEMANN

1927 (lithograph)
Indiana State Library
Patron: WFMT Radio

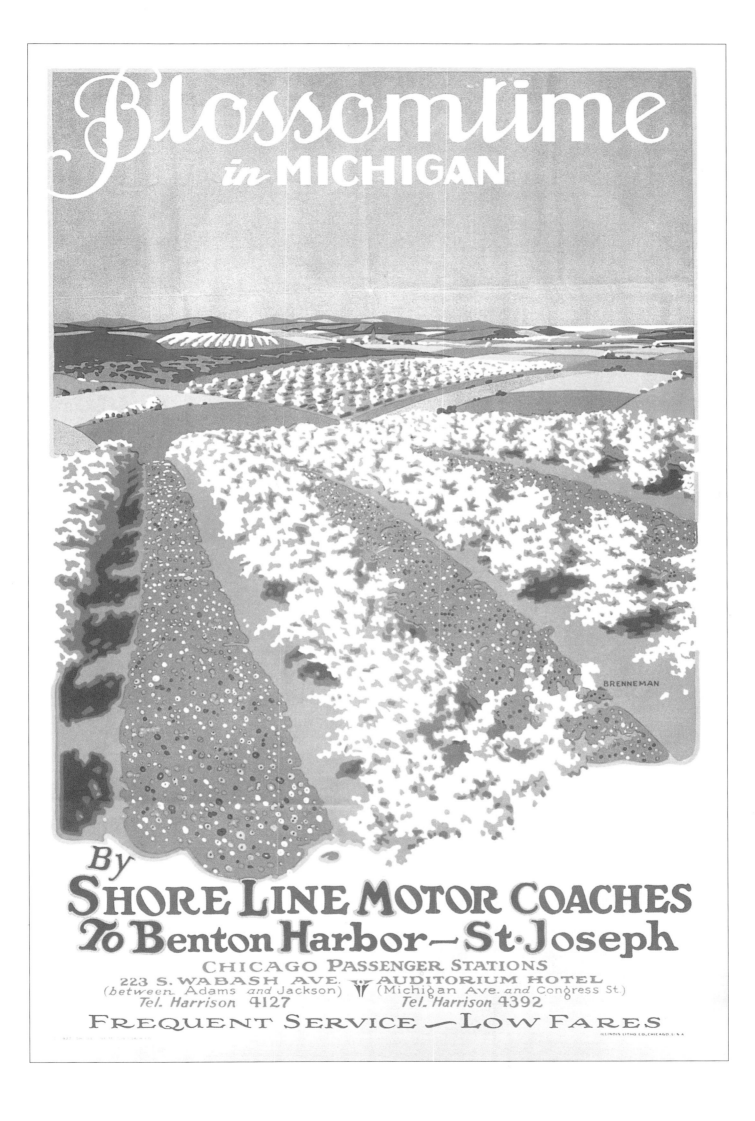

*Autumn in the Dunes by South Shore Line*

Ivan V. Beard

1928 (lithograph)
Calumet Regional Archives
Indiana University Northwest
Patron: Northwest Indiana Forum

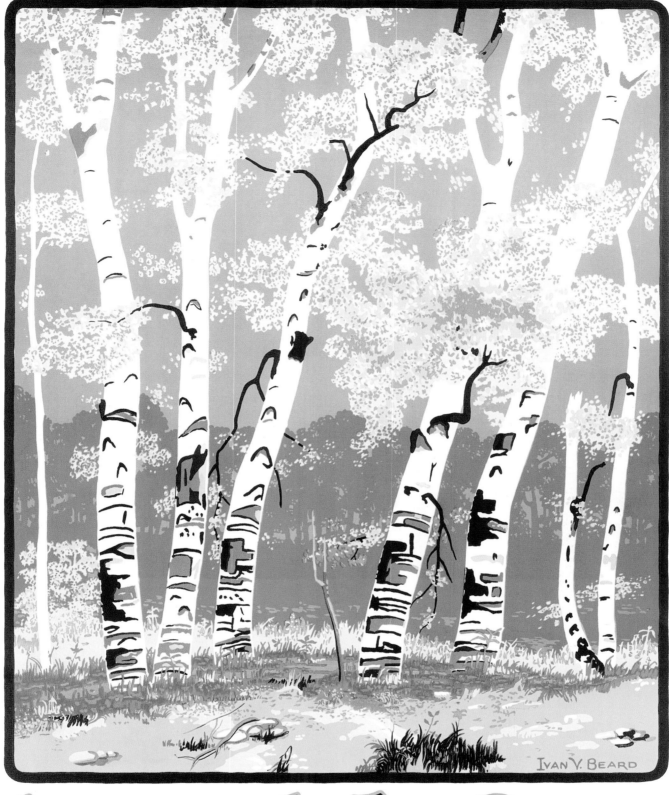

IVAN V. BEARD

# AUTUMN IN THE DUNES
## ᵇʸ SOUTH SHORE LINE

**FAST LIMITED TRAINS FROM CHICAGO**
TO SOUTH BEND, IND. LEAVING ILLINOIS CENTRAL RANDOLPH ST. STATION AND
STOPPING AT VAN BUREN, ROOSEVELT ROAD, 53ʳᵈ 63ʳᵈ AND KENSINGTON

© 1928 CHICAGO, SOUTH SHORE & SOUTH BEND RAILROAD            ILLINOIS LITHO. CO. CHICAGO. U.S.A.

*Duneland Beaches by South Shore Line*

LESLIE RAGAN

1928 (lithograph)
Calumet Regional Archives
Indiana University Northwest
Patron: Phil Smidt & Son, Inc

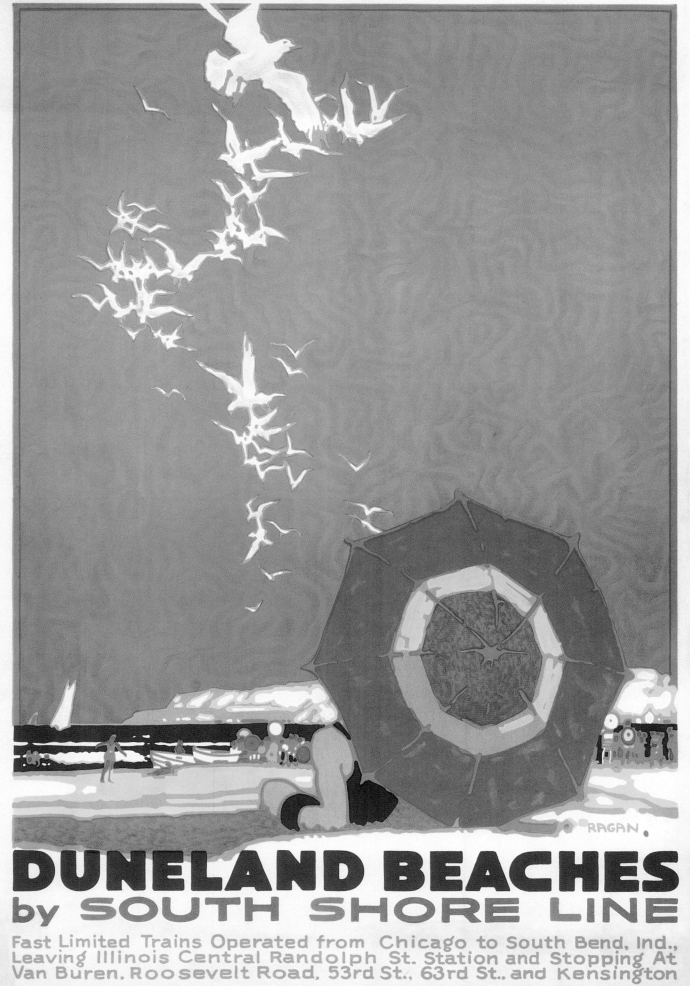

*Winter Sports in the Dunes by South Shore Line*

OTTO BRENNEMANN

1928 (lithograph)
Calumet Regional Archives
Indiana University Northwest
Patron: Northwest Indiana Forum Foundation, Inc.

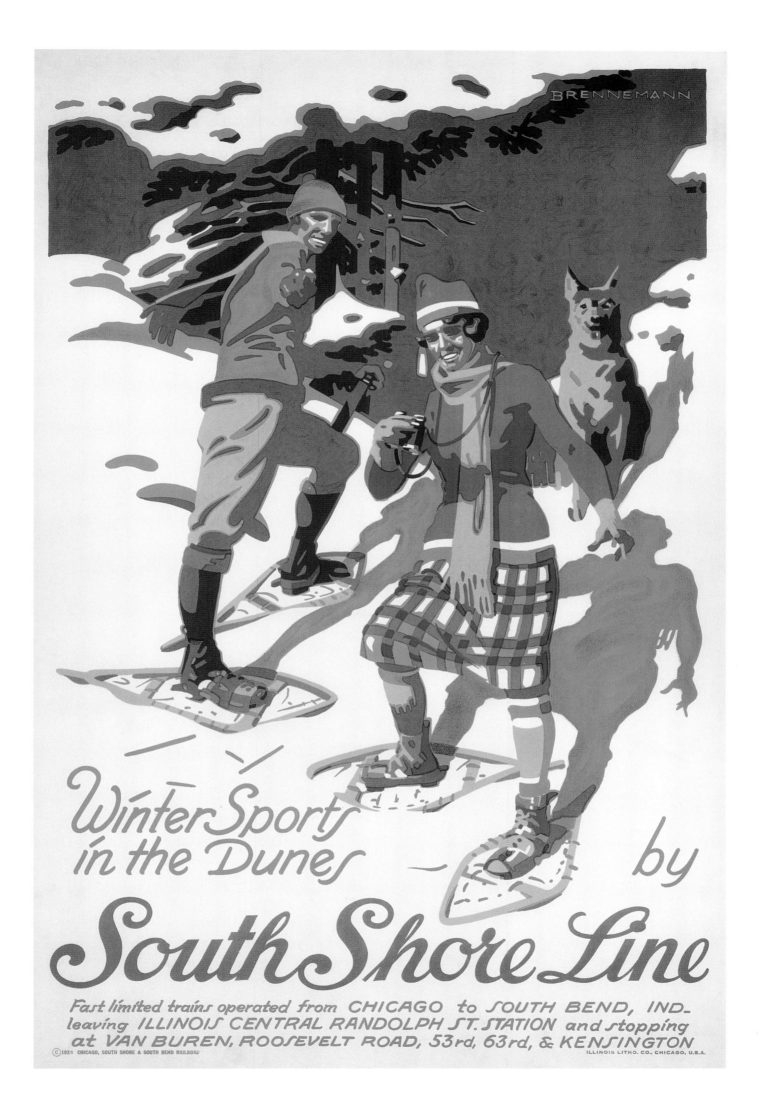

*Spring in the Dunes by South Shore Line*

RAYMOND HUELSTER

1928 (lithograph; ICHi-27100)
Chicago Historical Society

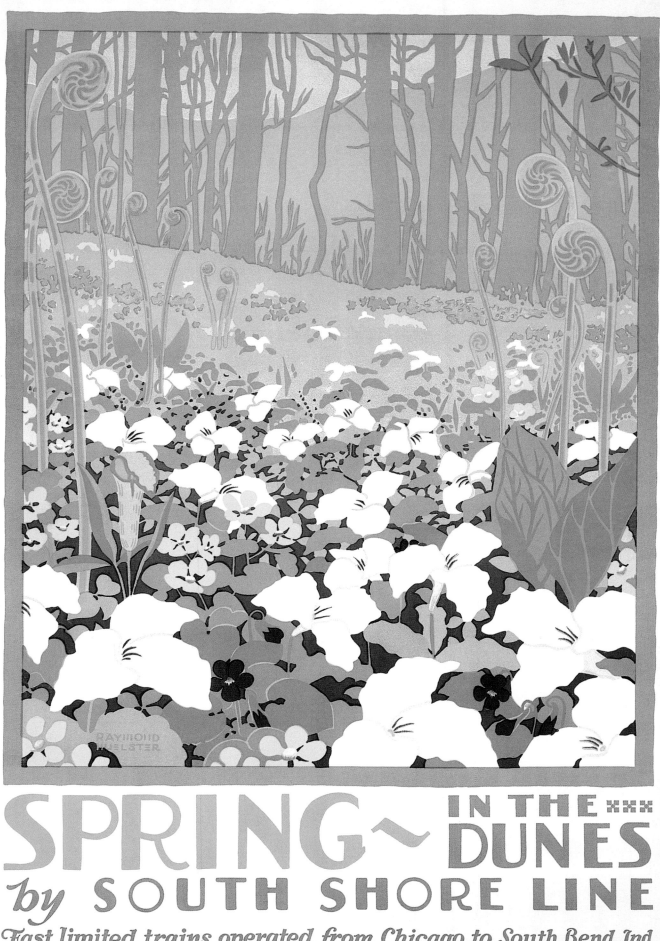

SPRING~ IN THE xxx
DUNES
by SOUTH SHORE LINE

Fast limited trains operated from Chicago to South Bend Ind.
leave Illinois Central Randolph Street Station, and stop
at Van Buren, Roosevelt Rd., 53rd St., 63rd St., and Kensington

*The Steel Mills by South Shore Line*

CARROLL T. BERRY

1928 (lithograph; ICHi-24862)
Chicago Historical Society
Patron: WFMT Radio

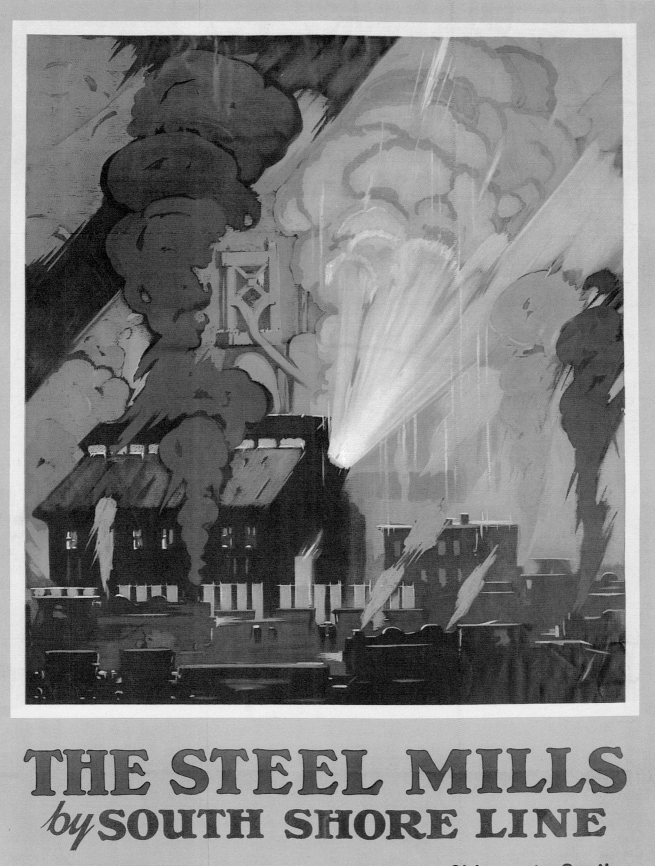

# THE STEEL MILLS
## by SOUTH SHORE LINE

Fast limited trains operated electrically from Chicago to South
Bend, Ind., leaving Illinois Central Randolph St. Station and stopping
at Van Buren, Roosevelt Road, 53rd., 63rd., and Kensington

**Dining Car Service**                    **Parlor Car Service**

*I got off @ Roosevelt Rd*
*— Central Station (now gone)*

*Ski Meet: Ogden Dunes by South Shore Line*

Emil Biorn

1929 (lithograph)
Calumet Regional Archives
Indiana University Northwest

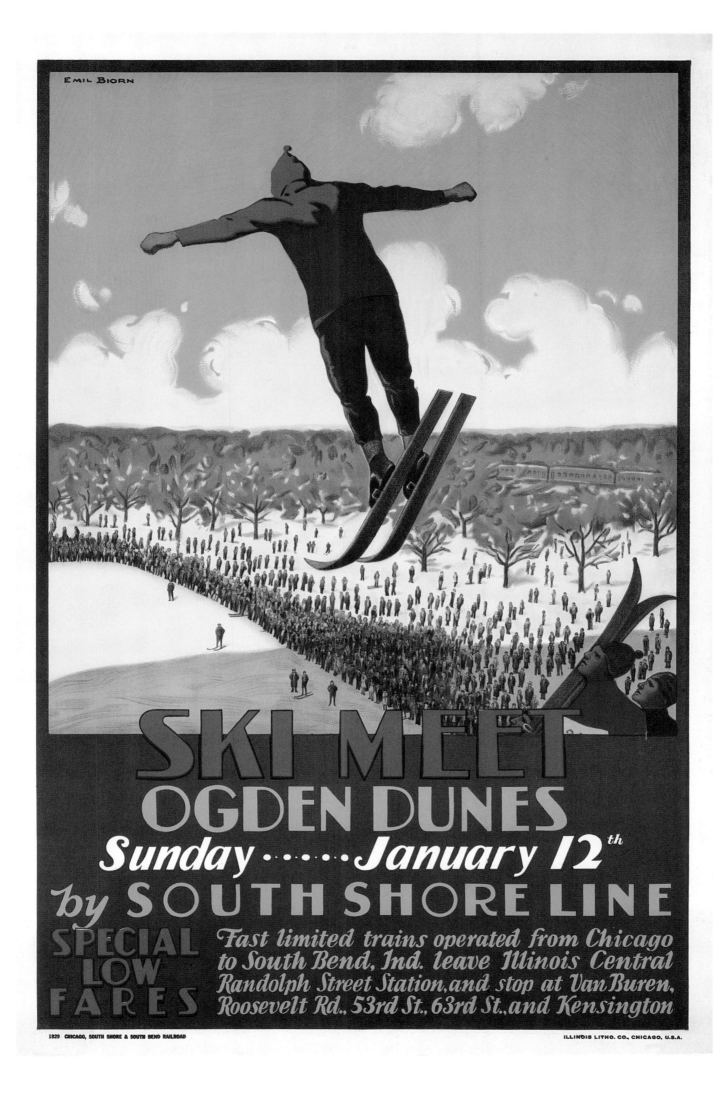

*Winter Sports by South Shore Line*

WALTER GRAHAM

1929 (lithograph; ICHi-27101)
Chicago Historical Society
Patron: WBBM-AM Radio

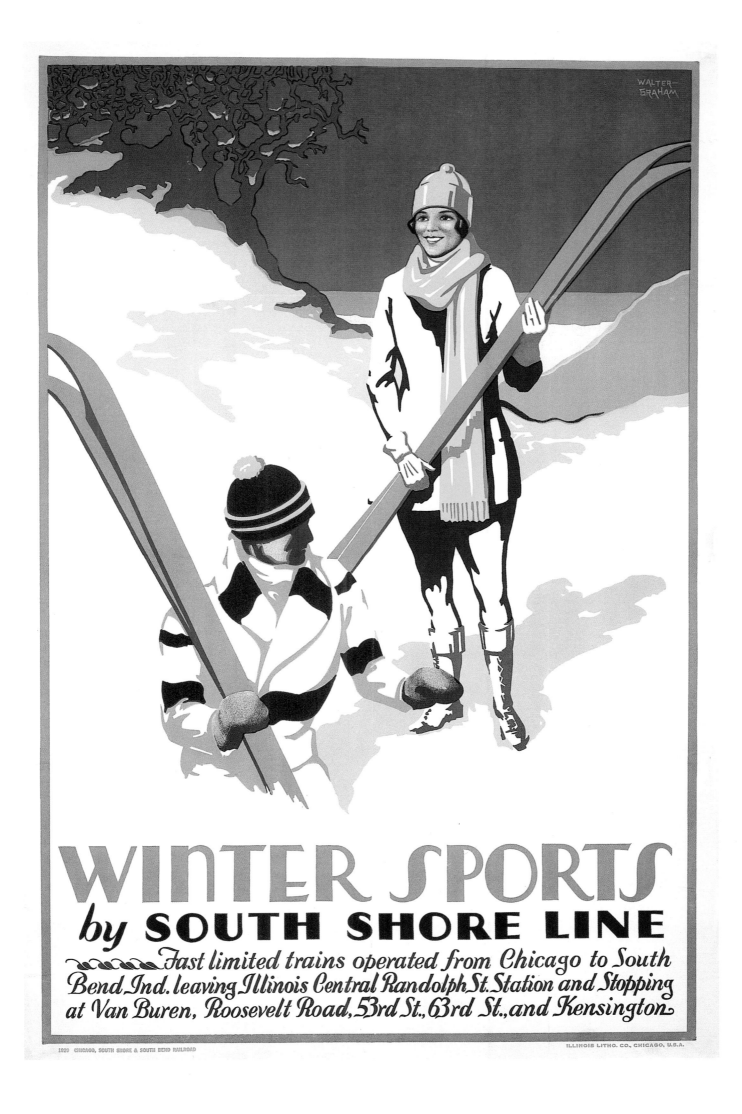

*Indiana Dunes State Park by South Shore Line*

RAYMOND HUELSTER

1929 (lithograph; ICHi-27102)
Chicago Historical Society
Patron: WBBM-AM Radio

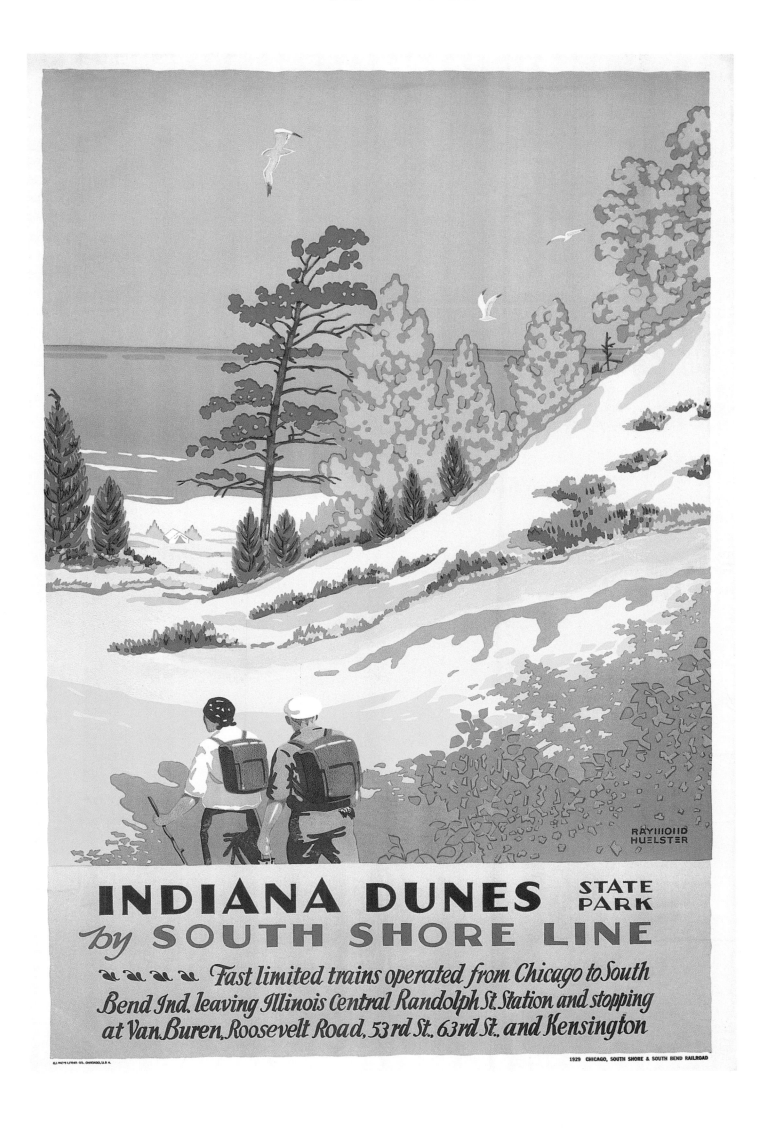

*Spring in the Dunes by South Shore Line*

Otto Brennemann

1929 (lithograph; ICHi-27104)
Chicago Historical Society
Patron: First National Bank of Valparaiso

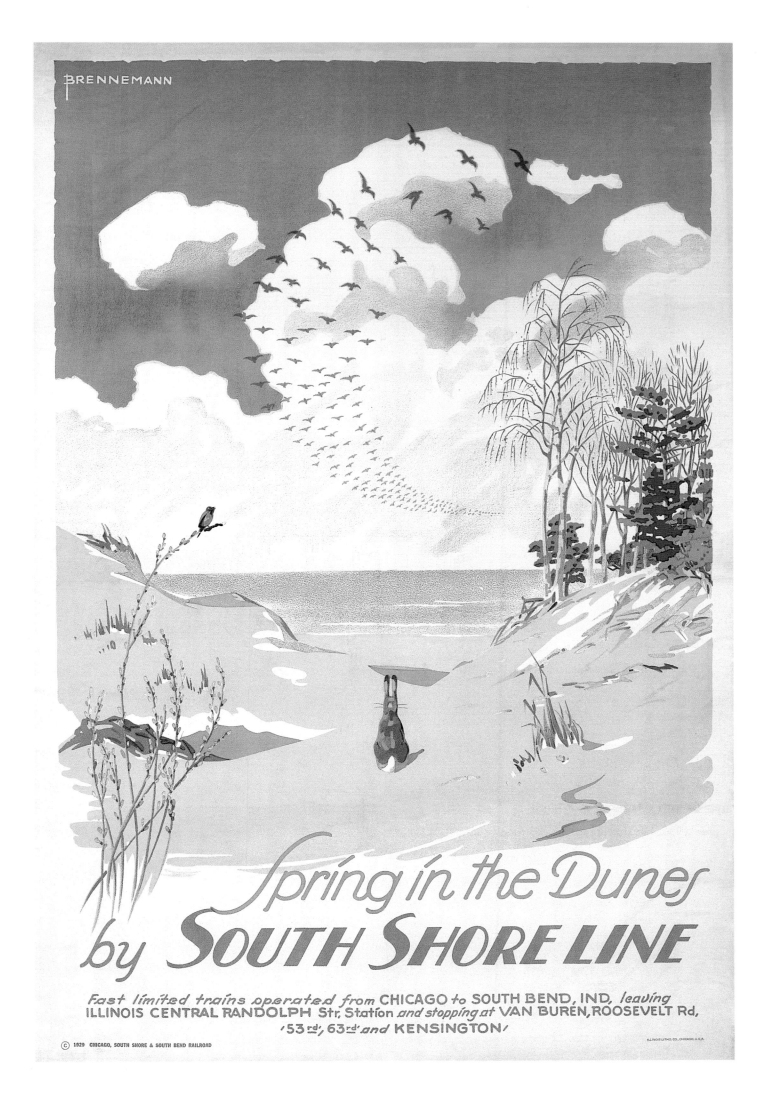

*Outward Bound by South Shore Line*

RAYMOND HUELSTER

1929 (lithograph; ICHi-27103)
Chicago Historical Society
Patron: Sheffield Press Printers and Lithographers, Inc.

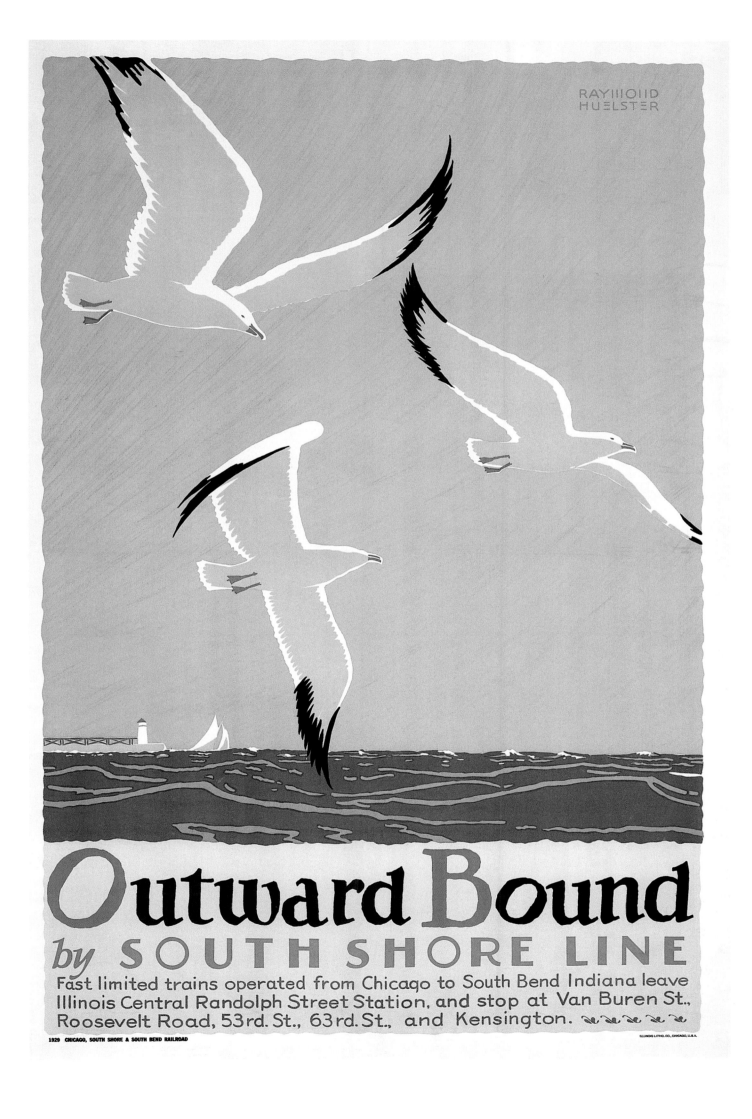

*Faithful Service: South Shore Line*

Mitchell A. Markovitz

1984 (lithograph)
Chicago SouthShore & South Bend Railroad

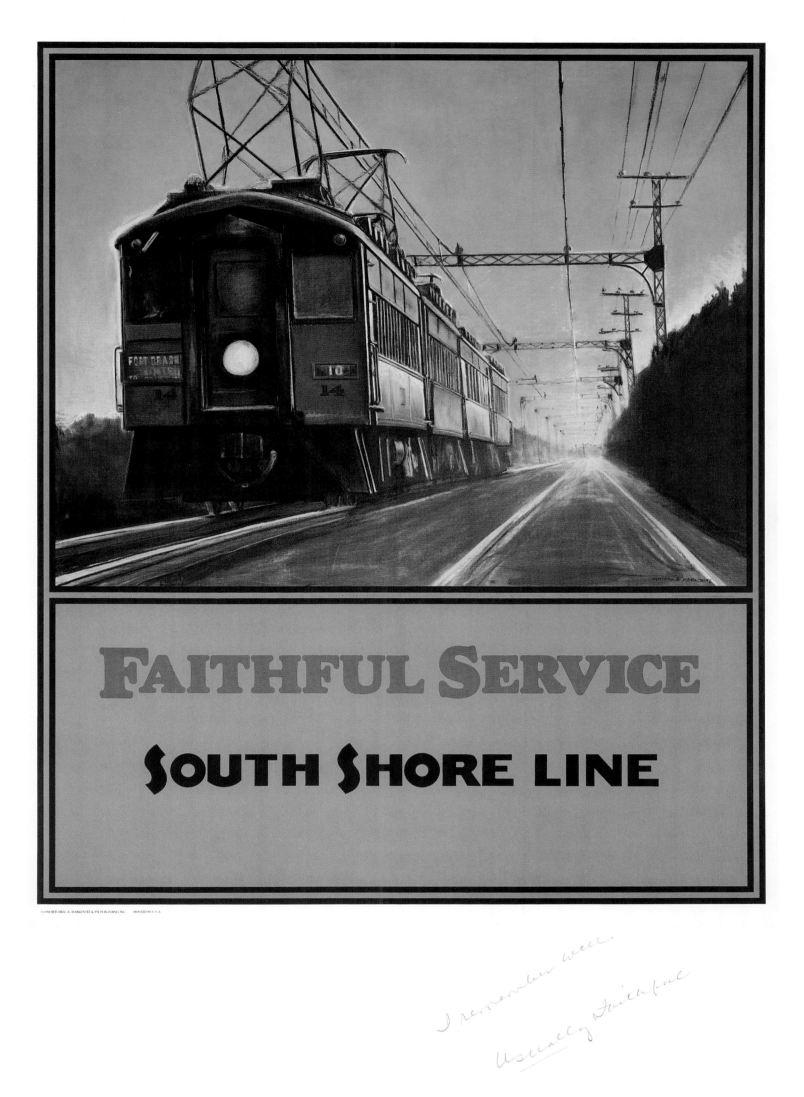

# FAITHFUL SERVICE

## SOUTH SHORE LINE

I remember well...

Usually faithful

*Taking Care of Business*

Mitchell A. Markovitz

1992 (lithograph)
Chicago SouthShore & South Bend Railroad

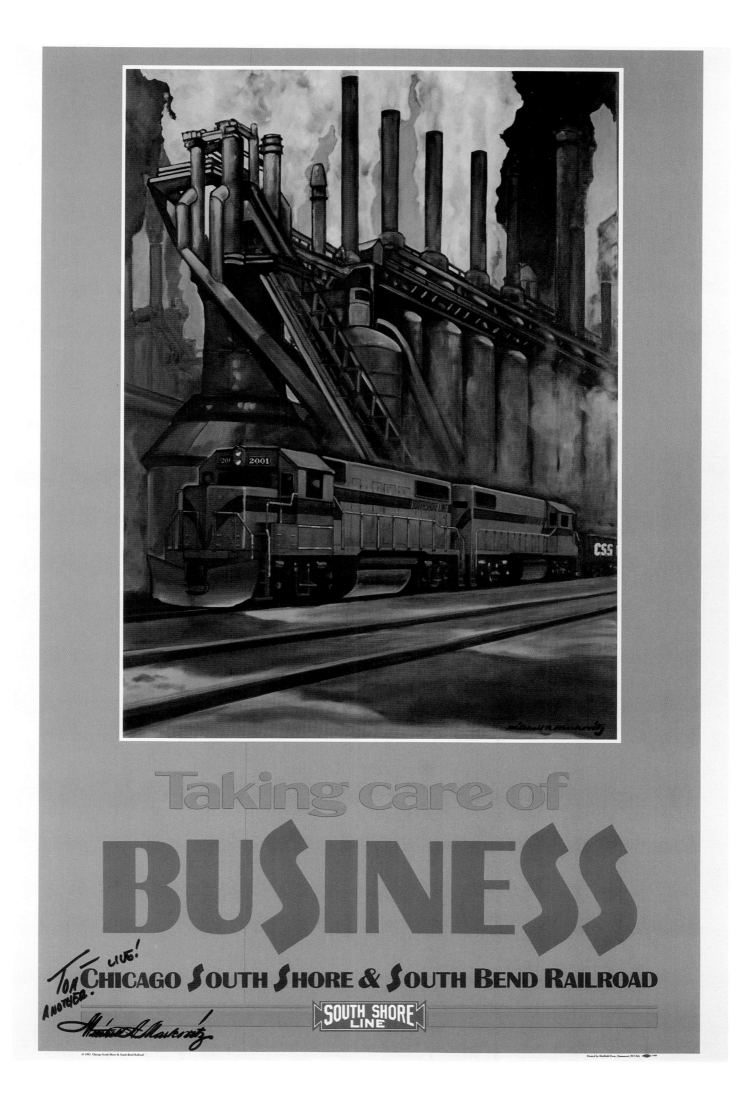

Taking care of
BUSINESS

CHICAGO SOUTH SHORE & SOUTH BEND RAILROAD

SOUTH SHORE
LINE

*Recreation: Just around the corner along the South Shore Line*

Mitchell A. Markovitz

1997 (lithograph)
Lake Erie Land Company

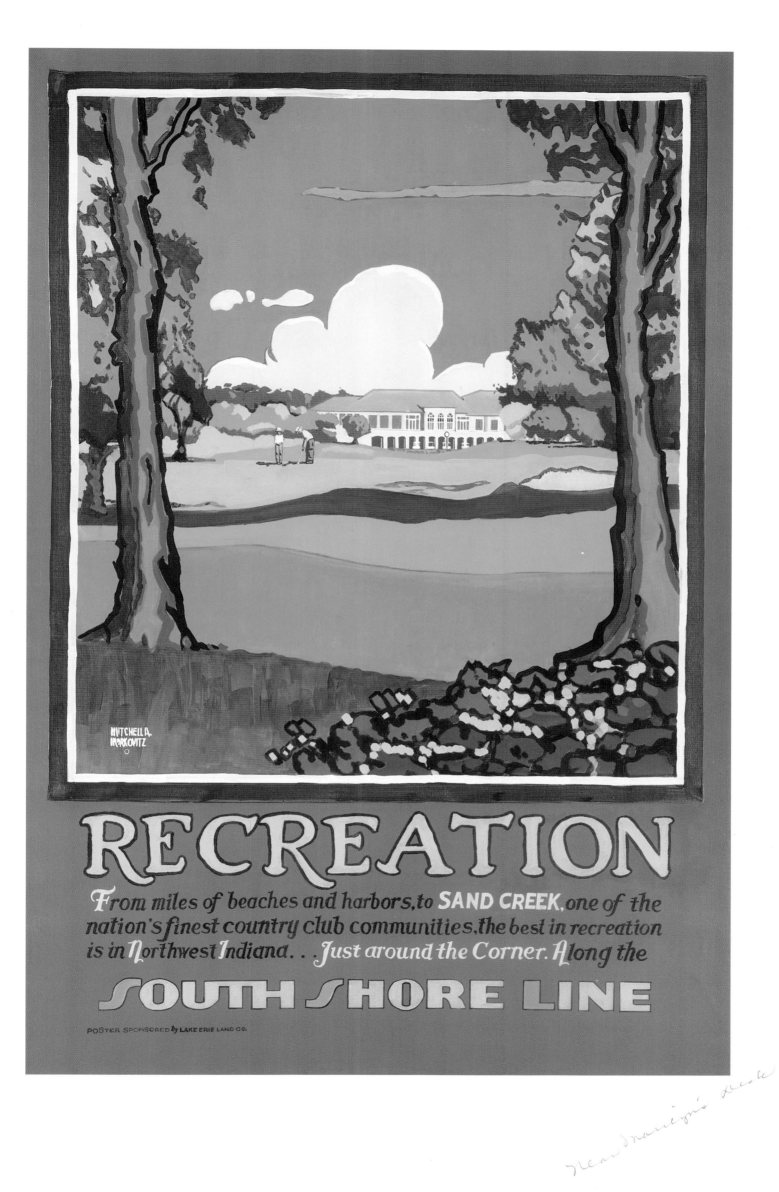

*Just around the Corner rests Indiana's Crescent Dunes . . . along the South Shore Line*

MITCHELL A. MARKOVITZ

1997 (lithograph)
Northern Indiana Public Service Company

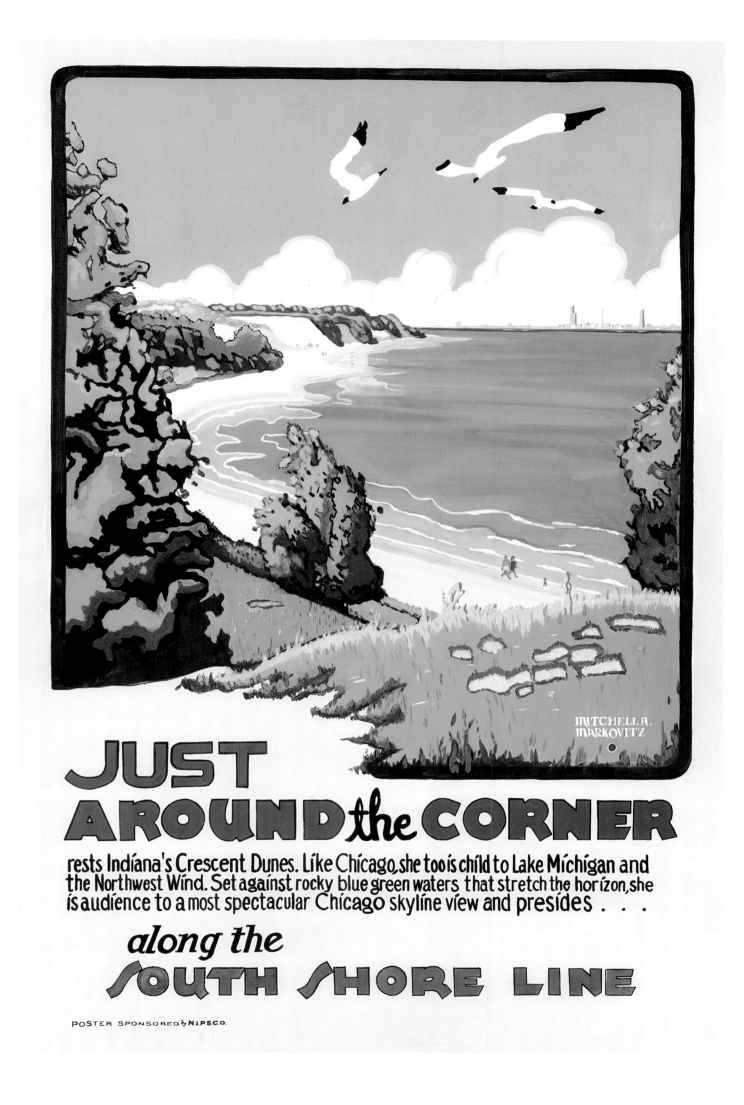

# JUST AROUND the CORNER

rests Indiana's Crescent Dunes. Like Chicago, she too is child to Lake Michigan and the Northwest Wind. Set against rocky blue green waters that stretch the horizon, she is audience to a most spectacular Chicago skyline view and presides . . . .

## along the SOUTH SHORE LINE

POSTER SPONSORED by N.I.P.S.C.O.

*Chicago's Neighboring South Shore: Just around the corner along the South Shore Line*

MITCHELL A. MARKOVITZ

1997 (lithograph)
Lake County Convention and Visitors Bureau

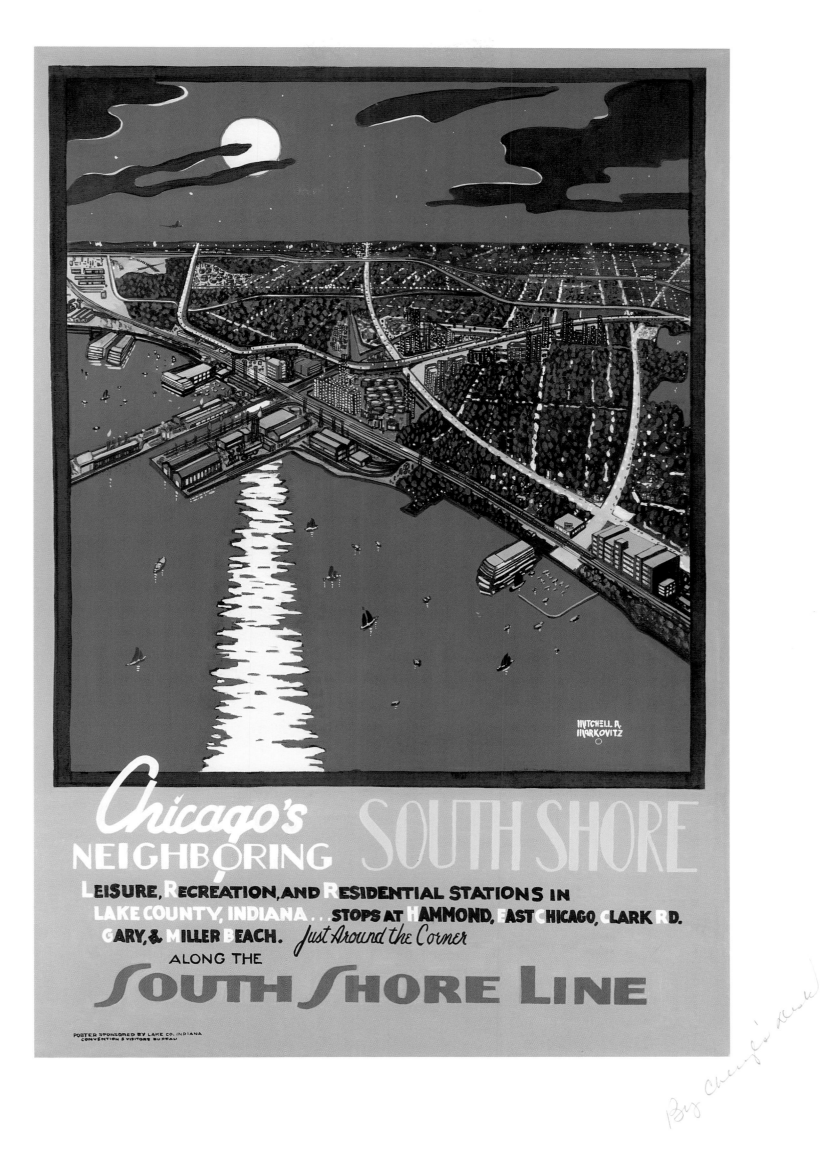

*Hoosier Prairie: A National Landmark. Just around the corner . . . along the South Shore Line*

ALICE PHILLIPS

1997 (lithograph)
Sand Ridge Bank

# HOOSIER PRAIRIE
## A NATIONAL LANDMARK

This Nature Preserve is located in Griffith, Indiana. The Prairie marsh and oak savannah has 335 acres of wild flowers, cattails, sedges and a variety of grasses indigenous to this area in Northwest Indiana. And it's just around the corner..

*along the*

## SOUTH SHORE LINE

POSTER SPONSORED by SANDRIDGE BANK

*Strength and Beauty: Just around the corner . . . along the South Shore Line*

JOHN RUSH

1998 (lithograph)
Inland Steel Company

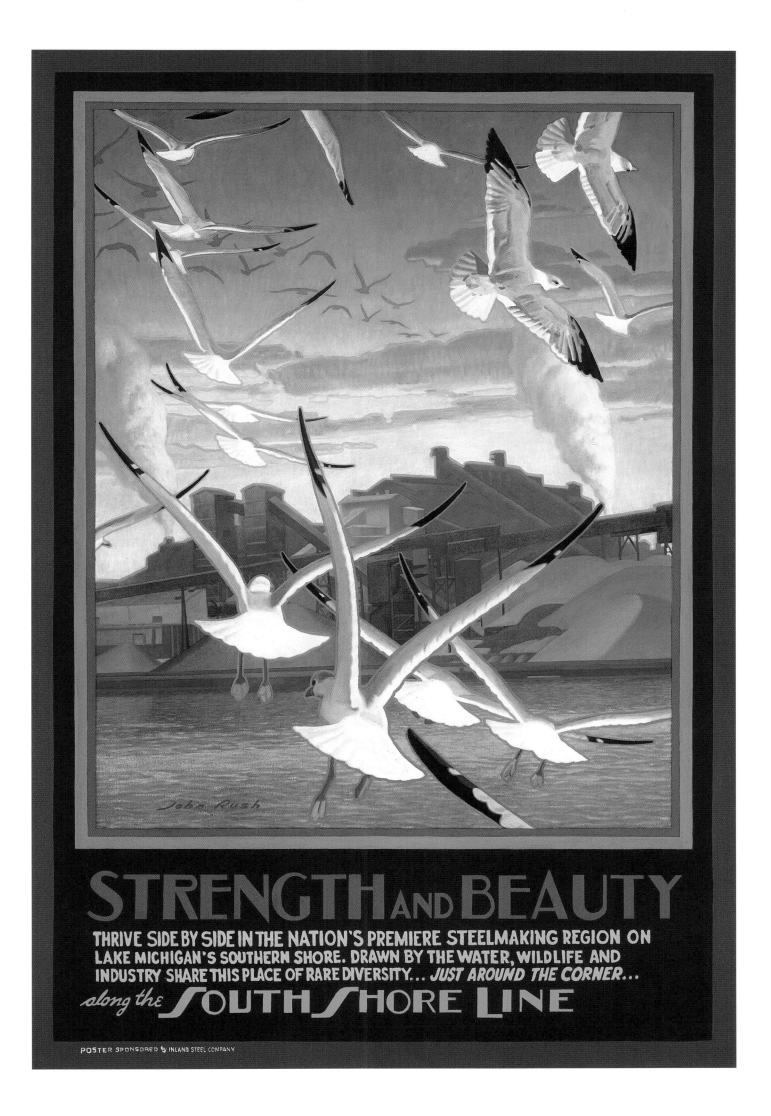

STRENGTH AND BEAUTY

THRIVE SIDE BY SIDE IN THE NATION'S PREMIERE STEELMAKING REGION ON LAKE MICHIGAN'S SOUTHERN SHORE. DRAWN BY THE WATER, WILDLIFE AND INDUSTRY SHARE THIS PLACE OF RARE DIVERSITY... *JUST AROUND THE CORNER...*

*along the* SOUTH SHORE LINE

# Suggestions for Further Reading

*Chicago, South Shore, and South Bend Railroad.* Chicago: Central Electric Railfans' Association, Bulletin No. 4, 1939.

*Chicago, South Shore and South Bend Railroad: How the Medal Was Won.* Chicago: Central Electric Railfans' Association, Bulletin No. 124, 1985.

Gruber, John. "Posters and Promotion." *Locomotive and Railway Preservation* 58 (March-April 1996): 51.

Gruber, John and J. J. Sedelmaier. "Chicago's Transit Posters." *Vintage Rails* 7 (Spring 1997): 49–51.

Hartt, Jay S. *The South Shore Line.* Chicago: Central Electric Railfans' Association, Bulletin No. 76, 1947.

Horachek, John D. *Six Decades Service on the South Shore Line: Oral History with C. Edward Hedstrom.* Arcadia, Ind.: John D. Horachek, C. Edward Hedstrom, Indiana Historical Society, Indiana Heritage Council, 1991.

Kaplan, Donald R. *Duneland Electric: South Shore Line in Transition.* Homewood, Ill.: PTJ, 1984.

Kay, Jane Holtz. *Asphalt Nation: How the Automobile Took Over America and How We Can Take It Back.* New York: Crown Publishers, 1997.

Lloyd, Gordon. *The Insull Chicago Interurbans: CA&E-CNS&M-CSS&SB.* Edison, NJ: Morning Sun Books, 1996.

Malloy, James A. "A Report of the Chicago, South Shore, and South Bend Railroad." Master's Thesis, University of Notre Dame, 1930.

McDonald, Forrest. *Insull.* Chicago: University of Chicago Press, 1962.

Olmsted, Robert P. *Scenes from the Shore Lines: North Shore Line, South Shore Line.* Janesville, Wisc., 1964.

———. *Interurbans to the Loop: North Shore Line, South Shore Line.* Janesville, Wisc., 1969.

Platt, Harold L. *The Electric City: Energy and the Growth of the Chicago Area, 1880–1930.* Chicago: University of Chicago Press, 1991.

Raia, William A. *Spirit of the South Shore.* River Forest, Ill.: Heimburger House Publishing Company, 1984.

Smerk, George M. *The Electric Interstate: An Update on the South Shore Railroad.* Offprint from *Indiana Business Review* 65 (Bloomington: Indiana University, 1990).

# About the Artists

## DALE FLEMING

Living in the Dunes, devoting full time to his art, Dale Fleming reflects the life around him in realistic paintings that show a gentle understanding of people, familiar dunes scenes, and places in Colorado he has adopted for his model railroad landscape. His sketch book is ever with him, and his friends and son Carl provide subject matter for many of his portraits.

Mr. Fleming's background includes years of study at the American Academy of Art in Chicago and with several area artists. He has exhibited at a number of galleries in Chicago, Indiana, Michigan, Kentucky, Colorado, and California. In addition, he has illustrated two children's books for the Albert Whitman Company and a book on the Denver, South Park & Pacific Railroad.

His special love is the dunes area where he lives, and his acrylic paintings combine the delicate skill of his earlier water colorist days with the colors of oil paintings.

## MITCHELL A. MARKOVITZ

Born to a commercial artist and interior designer, it was Mitchell A. Markovitz's destiny to become an artist. After serving as an apprentice in his father's art studio and formal education at the American Academy of Art and Chicago Academy of Fine Art, Mitch struck out on his own as a painter and illustrator. He pursued additional education at the University of Wisconsin–Milwaukee, in oil painting and fine art.

Along the way, however, he combined his love of art with a second powerful interest, that of a railroader. For nearly thirty years, Mitch has worked for several railroads, including the Chicago & North Western Railway, the Milwaukee Road, and, of course, the Chicago, South Shore & South Bend Railroad. At the South Shore Line, Mitch enjoys the opportunity to combine his art career with working on a railroad. In addition to his duties as locomotive engineer and trainman, Mitch continues his work as an artist and commercial illustrator, serving as art director and graphic consultant for the Northern Indiana Commuter Transportation District, which operates the South Shore Line.

Mitch has exhibited his work at numerous shows in Chicago, New York, and Indianapolis. His talent has also been sought by several corporations, and his art has appeared in the collections of Modern Businessmen's Insurance, Anacostia and Pacific Corporation, and the Northern Indiana Public Service Company. His current endeavor focuses on producing paintings for the new poster campaign undertaken by the Northwest Indiana Forum.

## ALICE PHILLIPS

Alice Phillips is a familiar name in the Northwest Indiana arts community. She received her art education at the American Academy of Art and has been a "working artist" for the past twenty-six years. Her art work is realistic in style and has been included in local and national juried art shows. Alice is also represented in local and Midwest private and corporate collections. She has won numerous awards, from the Midwest Pastel Society's Award of Distinction to the Award of Excellence presented by the Area Artists Association. Alice's work has been exhibited at the Valparaiso University Museum of Art, the Municipal Art League of Chicago, and the Art Institute of Chicago.

Alice's personal philosophy as an artist is captured in her statement, "My current work is involved with forms found in nature. I place strong emphasis on lighting. Light on form brings me great joy, and if I can convey this to the viewer, I am pleased."

## JOHN RUSH

A native of Indianapolis, John Rush graduated from the University of Cincinnati with a bachelor's degree in industrial design in 1971. After working for the City of Cincinnati as a park designer, he earned a degree in illustration from Art Center College of Design in 1975. From there, he moved to Chicago, working as an illustrator for several large art studios. In 1978, he pursued a freelancing career in New York and Chicago. In 1988, he began producing intaglio prints and received a commission from the government of France for its bicentennial celebration in 1989. During the 1990s, John began exhibiting his paintings through the Eleanor Ettinger Gallery in New York. He completed his first mural, depicting the Battle of Lexington and Concord, for the U.S. National Park Service in 1993.

John's illustrations have won awards from the Society of Illustrators, Society of Publication Designers, and the Chicago Artists Guild. His work has appeared in numerous graphic arts publications and has been exhibited throughout the United States, Europe, and Asia. Many of his paintings reside in corporate and private collections. He continues to divide his time between painting, illustration, and printmaking.

## Poster Retailers

*Many of the posters in this book are available for purchase as reproductions from the following retailers:*

Ben Franklin Crafts
219 Broadway
Chesterton, IN 46304
(219)926-2629

Brickie Photo
Gallery and Portrait Studio
216 Main Street
Hobart, IN 46342
(219)942-0004

Chicago Historical Society Gift Shop
Clark Street at North Avenue
Chicago, IL 60614
(312)642-4600

Northern Indiana Arts Association
1040 Ridge Road
Munster, IN 46321
(219)836-1839

Northern Indiana Commuter Transportation District
33 E. U.S. Highway 12
Chesterton, IN 46304
(219)926-5744

Poster Plus
200 S. Michigan Avenue
Chicago, IL 60604
(312)461-9277

# *"Just around the Corner"*

A Marketing Campaign for Northwest Indiana featuring new poster art in the tradition of the South Shore Line posters of the 1920s

We gratefully acknowledge the following sponsors of new posters featuring unique views of Northwest Indiana:

Chicago SouthShore & South Bend Railroad
City of Hammond
The Community Hospital
First Chicago NBD Corporation
Inland Steel Company
Kankakee Valley Workforce Development
Lake County Convention and Visitors Bureau
Lake Erie Land Company
Mitchell A. Markovitz
Matthews & Rae, Inc.
North Coast Distributing
Northern Indiana Public Service Company
Northwest Indiana Water Company
The Post-Tribune
Saint Margaret Mercy Healthcare Centers
Sand Ridge Bank
Stanrail Corporation
Tradewinds Affirmative Industries
Valparaiso University

RONALD D. COHEN, Professor of History at Indiana University Northwest, is author of *Children of the Mill: Schooling and Society in Gary, Indiana, 1906–1960*, co-author of *The Paradox of Progressive Education* and *Gary: A Pictorial History*, and editor of *"Wasn't That A Time!" Firsthand Accounts of the Folk Music Revival* and *Red Dust and Broadsides: A Joint Autobiography*.

STEPHEN G. McSHANE has served as Archivist/Curator at the Calumet Regional Archives, Indiana University Northwest, since 1982. His works on the history of Northwest Indiana include *Skinning Cats: The Wartime Letters of Tom Krueger* (ed. with James B. Lane) and "We'll Stick with Dick: Earl Landgrebe, Watergate, and the Vocal Minority" in *Traces of Indiana and Midwestern History*.

BOOK AND JACKET DESIGNER: SHARON L. SKLAR

EDITOR: MICHAEL W. LUNDELL

TYPEFACE: ADOBE CASLON / HUXLEY

COMPOSITOR: SHARON L. SKLAR

PRINTER: FOUR COLOUR IMPORTS

I worked at
Standard Oil (American Oil)
910 S. Michigan   12/60 - 6/65
(went to Bell Steel)
1st 2 years Valley rode S.S.
next 2½ yrs was in carpool most
of time but still occasionally rode
S.S.

Many openings and much people.
watching and interacting - many memories
(the old orange trains - gliding off the
tracks in (Hammond) - many memories)
fire extinguisher! + no air conditioning!
Sundays few riders except for commuters!
stops (4?) in Illinois - gliding off the
to drop off @ those stops - in a.m. allowed
to pick up a across stops (Hegewisch) at night
18th Street). Roosevelt end of Civic).
We'd have to stand 'til last of people
at (Hegewisch. I could sleep standing.)

We got off at (18th St/Roosevelt nr where we'd
I.C. central station used to be where we'd walk up
not over I.C. central station through (Curries) up in air - wooden
performs, etc. one of the air tunnels (Curves) up in air - wooden
worse - up in the air tunnels (curves) up in air - wooden
a time women side me wear elders - and, a
steps!

bye, through the Hegewisch area and like the
of steam weekend one Lever Bros Plant - with long
swamps, cesspool pools - birds & animals in the
greens almost everywhere in summer heat.

Many more times!

from Dorothee
12/25/98

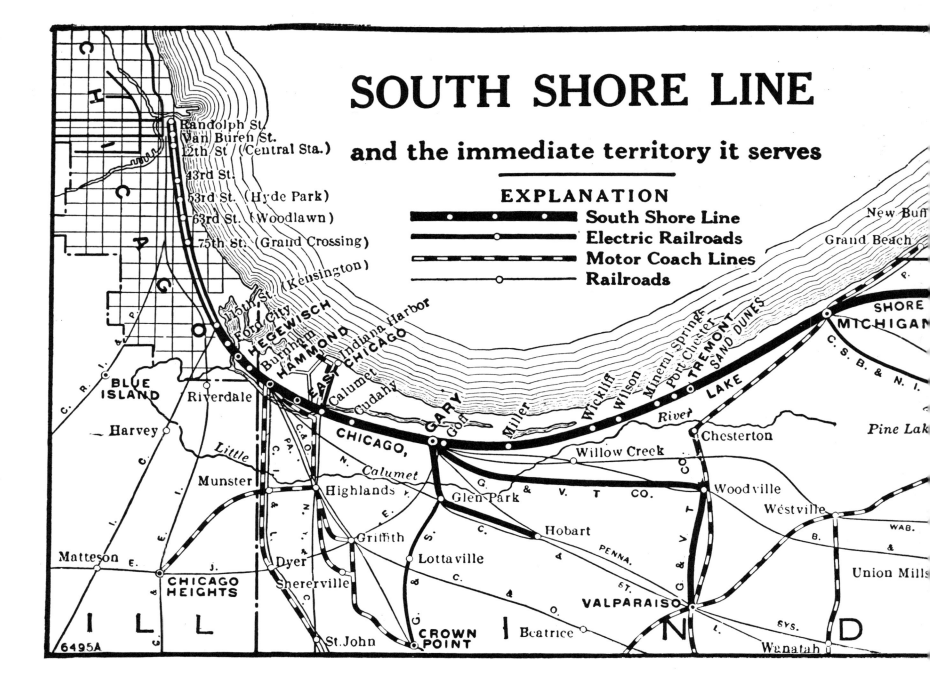

# SOUTH SHORE LINE
## and the immediate territory it serves

### EXPLANATION

| | |
|---|---|
| ●━━━●━━━●━━━● | South Shore Line |
| ━━━○━━━━━○━━━ | Electric Railroads |
| ━━━▪━━━▪━━━▪━━ | Motor Coach Lines |
| ━━○━━━○━━━○━━ | Railroads |

CHICAGO

Randolph St.
Van Buren St.
12th St. (Central Sta.)
33rd St.
53rd St. (Hyde Park)
63rd St. (Woodlawn)
75th St. (Grand Crossing)
103rd St. (Kensington)

Ford City
Hour St.
HEGEWISCH
Burnham
HAMMOND
Indiana Harbor
EAST CHICAGO
Calumet
Cudahy

BLUE ISLAND
Riverdale
Harvey
Little Calumet
Munster
Highlands
Matteson
Dyer
CHICAGO HEIGHTS
Shererville
Griffith
Lottaville
St. John
CROWN POINT

CHICAGO,
GARY
Golf
Miller
Glen Park
Hobart
Beatrice

Willow Creek
Wickliff
Wilson
Mineral Springs
Port Chester
TREMONT
SAND DUNES
River
LAKE

Chesterton
Woodville
Westville
Valparaiso
Wanatah
Union Mills

New Buff
Grand Beach
SHORE
MICHIGAN
C. S. B. & N. I.
Pine Lak

G. & V. T. CO.
PENNA.
WAB.
&
SYS.

ILL
IND

6495A